CONTENTS

TIME
AND
LIGHT
NIGEL WARBURTON

I'm interested in that moment of peace which descends when someone is reading
a book, or observes flowers in a vase, and a certain quality of light comes into the
room, some transcendent instant—and then it passes. I want to preserve a space
for those special moments —the pictures are embodiments of them.

Garry Fabian Miller[1]

How we spend our time is the basic moral question and one that pre-occupies Garry
Fabian Miller. His work may seem to stand apart from domestic routine and, indeed,
from human concerns. Its initial impact is via form, colour, and light implying
values beyond mundane reality. This is the essence of abstraction: that it does not
refer directly to the world of appearances, but only to the immediately visible, if
at all, via metaphor and symbol. Since Vassily Kandinsky's manifesto "Concerning
the Spiritual in Art", 1911, it has been a commonplace that abstract art has spiritual
associations, and that it aspires to the condition of music—as the philosopher Arthur
Schopenhauer believed all art should. For Schopenhauer music was the supreme
art form, the one that was most capable of putting us in touch with the World as Will
that lies behind the 'veil of Maya'. Similarly, for Kandinsky the charm of colour and
formal play were the superficial aspects of abstract art. Its deeper meanings, though,
were brought about by the vibrations of the soul, an inner resonance, rather than by
any tie to the World as Will. Both theorists attributed almost mystical powers to the
abstract arts and their ability to trigger transcendence. Both believed that music
was the supreme art form.

It is tempting to read Garry Fabian Miller's art as standing in this tradition. His
methods of working with simple elements combined and re-combined over time
bear strong analogies with musical compositions. His vocabulary of the circle,

Hameldown, Dartmoor
Winter 2005

square and divided square, using rich reds, yellows, oranges, blues, and blacks, does not overtly link to the visible, except, perhaps, via allusions to the sun, moon and horizon. His palette is for the most part closer to the intense blues and oranges of damsel and clown fish, or to the brightly coloured fluorescent lights of a Dan Flavin installation than it is to the browns, greens and greys of Dartmoor, where he lives. Yet his is a more grounded, less ethereal art than at first appears. It is intimately tied to lived time, the rhythms of nature and place, and the everyday—much more so than many viewers realise. These images seem infused with profound meaning, but that meaning is not religious, mystical or otherworldly: it has humanity at its core and takes its inspiration from lived existence not from a promise of rewards in a world to come.

To appreciate this, we need to know something about the man and the way he has chosen to live. We do not experience any art as a pure aesthetic experience, but rather as historically located, the work of a particular artist with specific concerns—nor should we. *Pace* Clive Bell, art is not just Significant Form, patterns of lines shapes and colours that lie charged for all eternity with the ability to produce an aesthetic emotion in the sensitive viewer. Art always has a context and is tied to the world. In the realm of art, what you see isn't necessarily all you get. Artists *mean* something by their work, even if precisely what that is lies open to wide interpretation. Or at least some interpretations are more appropriate than others. While it is possible to enjoy the sequence of, say, *Year One*, simply as a succession of striking patterns, this approach neglects much that can illuminate the work and most of the significance it has for the artist. Some artists self-consciously divorce their art from other aspects of their lives, but for Fabian Miller there is little if any separation between the two. This art has a conceptual element that ties it to the daily life of its creator.

Fabian Miller has a strong affinity with the Quaker tradition and its focus on the 'inner light' of conscience. The Quaker values of simplicity, honesty, hard work, family, and meditation, underpin his practice, though it is entirely secular and stands apart from religion. The closest he comes to the divine is in his reverence for light, and particularly for daylight in all its variety. This borders on a personal religion. For the last 20 years he has lived with his family on the edge of Dartmoor deliberately distancing himself from the distractions of city life. In this tranquil setting he has doggedly pursued his vision making occasional forays into the art world, but avoiding becoming too entangled. His work space is a large well-lit white-walled studio providing optimal viewing conditions for new pieces, combined with a small darkroom. This free-standing building overlooks the moor. Every day he walks in the countryside, and spends time making and contemplating images. These activities are connected—the walking, image-making and contemplation.

Although not overtly a land artist, that is a direction he might have taken, and he continues to have strong affinities with the ideas that fuel this movement, though his medium is now light rather than stones, leaves or soil. In the mid-to late 80s he exhibited frequently alongside Andy Goldsworthy including in Land Matters, 1986—a show that Fabian Miller curated. In the same year Goldsworthy made work both in and around 'The Barn' an exhibition space in Fabian Miller's garden. Two years later both were commissioned by the Victoria and Albert Museum to create new work for Artists in National Parks. These activities established Fabian Miller

as an environmental artist. He was at this time projecting light through translucent plant leaves to produce Cibachrome prints of great beauty in which he took Henry Fox Talbot's observation that photography allows the objects "to print themselves" literally. Fox Talbot had himself made "photogenic drawings" of botanical subjects by placing plants on light sensitive paper, a tradition carried on most notably by Fox Talbot's contemporary Anna Atkins with her striking blue cyanotypes of British algae. Both Fox Talbot and Atkins used the technique to document the plants they found; Fabian Miller's camera-less images, in contrast, were always part of an artistic practice and made in awareness of developments in contemporary art. His use of Cibachrome colour paper and the technique of projecting light through the specimens, combined with his interest in seasonal change, refreshed this tradition of the photogram and imbued it with metaphorical significance beyond its literal representation of flora. In some pieces multiple images set out in a grid were a rural version of Bernd and Hilla Becher's obsessive urban repetitions. In others the visual allusions seemed to be to the work of Karl Blossfeldt in his book *Art Forms in Nature*, though Fabian Miller's use of colour produced a very different effect from Blossfeldt's monochrome close-ups of buds, leaves and seed pods. He might have continued in this vein indefinitely, but in the early 1990s he modified his direction and began experimenting with more abstract compositions, eventually abandoning the literalness of the leaf prints altogether.

Fabian Miller's sensitivity to the patterns of light on the moors, the changing seasons, the clouds, rocks and vegetation all impinge on the work he makes today, but the representational link to the viewable world has become more oblique. At the same time he has developed a distinctive and original style based on the photogram. His pictures are not direct transcriptions, and the connection with nature is more cerebral than physical—even the light comes from an enlarger rather than the sun. They remain, however, to a large extent the product of his solitary walks and of his appreciation of the changing light and the turning of seasons. Daybreak and sunset take on a far greater significance in open countryside. In the qualities of these transitional times with their spectacular vistas he finds a symbol of transience, but also of the possibility of achieving something meaningful between sun up and sun down. The marking out of a day as a significant unit of time is made more poignant by a personal tragedy. In 1991 the Fabian Millers' second son Gabriel died within a day of his birth as a result of a genetic disorder known as Edwards Syndrome. The memory of that day colours and drives the work he has produced since.

> His life changed the nature of my life, and the day I spent with him altered my perception of the world. I think after that time what I was trying to reach for in my pictures was something which was located in the preciousness of being alive....

Garry Fabian Miller[2]

What Fabian Miller seeks now is not so much redemption, but a heightened awareness of instants of beauty and peace that can provide human solace, resolution and meaning. These moments of calm centred meditation become more affecting because of their essential transience. Each one has value. Cumulatively they make a life.

Spear
Summer 1998
Leaf, light, dye destruction print
30.5 x 30.5 cm / 12 x 12" (detail)

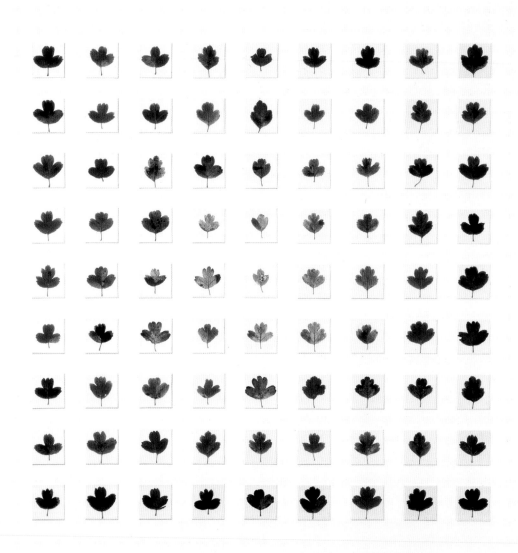

Split Thorn, the last leaves, the last
branch, the cuts, the scars, the wounding.
A gathering in for the healing.
Fallen in the Great Storm, 15–16 October 1987,
Green Park, London
Leaf, light, dye destruction print
153 x 153 cm / 60 x 60˝

James Joyce's notion of an epiphany "the most delicate and evanescent of moments" is pertinent here. The Epiphany is the moment when Christ's divinity was revealed. But in Joyce's non-religious version it is a special insight that arises directly from the everyday:

> Its soul, its whatness, leaps to us from the vestment of its appearance. The soul of the commonest object, the structure of which is so adjusted, seems to us radiant. The object achieves its epiphany.

James Joyce[3]

The moment of epiphany reveals a deeper meaning and coherence. These are the golden instants in anyone's life when a new perspective dawns, and for a few seconds things fall into place in a new way. In Biblical terms, the scales fall away from our eyes. These epiphanies are what Fabian Miller aspires to preserve and embody via a chemical conjuring trick performed alone in a small dark room.

For those unfamiliar with his working methods, it may not even be obvious that Fabian Miller uses photographic materials. His images are in the oldest tradition in photography—that of camera-less photography—a tradition that began with photography's inventors, including William Henry Fox Talbot, and was given new life by Modernism through the experiments of the Dadaist Christian Schad, the Bauhaus teacher and artist Laszlo Moholy-Nagy, and the Surrealist Man Ray. By placing objects on photographic paper complex patterns of silhouettes could be achieved using this more direct single-stage process. Schad gathered rubbish—rags, tickets, and waste paper—and let it print its own image. Tristan Tzara dubbed the results "Schadographs". Moholy-Nagy took this further by using liquids and lenses, treating light rather than the objects as his principal medium. For the Victorians photograms were essentially a means to document plant specimens; for the Modernists this was a new and exciting technique for producing art. The resulting images are direct traces of whatever was placed on them, more direct even than a photograph because the object has usually been in physical contact with the paper, and because there is no scope for interpretation between negative and print in a single stage process. The camera-less images, unlike photographs, tend to make familiar objects strange, either because of the detail they omit, or because of the distortions the process generates. Here was a way of making images that was distinctively modern, always tending to abstraction, and yet also produced chance effects and made the everyday objects poetic.

For Schad, Moholy-Nagy and Man Ray the photogram complemented their other artistic practice; for Fabian Miller it is his principal means of artistic expression. Part of his originality lies in the way he communicates his own pure vision within tight self-imposed limitations. He has also edged the photogram into the realm of pure abstraction. The simpler he makes the elements the greater range of artistic expression he achieves.

Surrounded by bottles, a light-projecting enlarger, sinks, trays, and the soon-to-be-obsolete paraphernalia of chemical photography, Fabian Miller works by letting light penetrate absolute darkness. His main medium is Cibachrome photographic paper (now known as Ilfochrome), a positive-to-positive paper using the dye

Nagy 1–3
Winter 1992
Water, light, dye destruction print
33 x 33 cm / 13 x 13˝ (each work)

Exposure (seven hours of light)
2005
Water, light, dye destruction print
161 x 190 cm / 63 x 75˝

Exposure (five hours of light)
1 July 2005
Water, light, dye destruction print
160 x 190 cm / 63 x 75˝

destruction process designed for printing from colour transparencies. Cibachrome produces results of great clarity, saturated colour and image stability. He uses this paper outside of any camera. Since it is sensitive to every frequency, no safelight is possible, so he moves around the familiar space in complete darkness. He pins the paper to the wall behind sheets of glass, and floods it with light that is refracted through coloured and clear vessels containing oil and water. The reds and blues are created using water in the coloured glass vessels, the yellows and oranges by shining light through a clear one containing engine oil. Effectively these are improvised colour filters. Exposure times range from a few minutes to more than 20 hours, different exposure times producing different hues and effects. Using stencils cut from pieces of cardboard, he manipulates the patterns of light and colour that will emerge after processing. Chance plays a role too as not every effect of the photochemical procedure can be anticipated. From these extremely basic elements he devises series of images that combine form, colour and light. Unlike the photograms of Moholy-Nagy and Man Ray, Fabian Miller's disguise their mode of production—there is no recognisable object visible in the finished works. The process of abstraction is complete. They are photograms, but it would be misleading to ask "what are they of?". They aren't *of* anything at all. That in part contributes to their otherworldy appearance. The indexical component here is relevant only in so much as it is to a large extent light. The vases and oil that produce the hues are means to an end as are the pierced discs, squares and rectangles of cardboard.

The glossy finished prints seem to have emerged from a high-tech laboratory, belying their humbler origins. Yet these are lovingly crafted objects, individually worked on in a rural setting. Until his recent large-scale work, every print was unique since the process uses no negative. Yet while the photographic apparatus is set up and the cut-outs in place, there is nothing preventing him running off further near perfect copies. The uniqueness of prints is *de facto* and not a product of the process. If he makes multiples in this way, though, they are usually subtly varied rather than literal copies.

Reproductions rarely do justice to the luminosity of the original pictures, which can be mesmerising. Light seems to emanate from them. Indeed, in a gallery context many viewers assume they are backlit, which they never are. They almost pulsate with the light or seem to float in mid-air, an effect enhanced by framing that gives depth. They seem to come from another world.

> Making something which is other, which seems to have come from an unknown place, is what I'm aspiring to do. Making things visible that have never been seen before.

> Garry Fabian Miller [4]

It is at the edges of shapes and where the colours blend in to each other, as with Mark Rothko's paintings, that Fabian Miller's art works its magic, and it is this that is hardest to capture in reproduction.

Fabian Miller's technique for producing photograms seemed fixed, but in 2004 when Ilford went into administration it appeared that the supplies of Cibachrome paper and chemicals might dry up for ever. Fabian Miller, an ardent Darwinist, began

to wonder if his species of camera-less photographer was about to become extinct in this changing technological environment. His pre-emptive solution was to evolve and take a step towards digital photography via large-scale editioned multiple prints made in collaboration with the digital colour specialist John Bodkin. This is a significant change—he recognises that he is at a pivotal moment in photography's history and wants to bring knowledge of the photochemical processes into the digital realm. In a decade from now, the idea of entering a darkroom to make images will probably seem quaint and archaic.

The immediate consequence was a transformation in the way he created large images. Previously, he had combined smaller prints to create a composite larger image in a kind of grid. The works in the *Exposure* series made in response to time he spent in the Hebrides on the island of Tiree in 2005, for example, each consisted of nine parts. Now by digital enlargement of the smaller prints he is creating seamless large-scale works that invite the viewer to enter the picture space. Earlier images were like leaves of a book, now hung low on the wall, they become large windows opening on to another space. He describes his new working method as a hybrid one since what was one-stage has become two-stage. The first stage remains the same, the creation of a small photochemical print using Cibachrome paper in the darkroom. In the second stage he collaborates with Bodkin to enlarge the image digitally while retaining the appropriate intensity of colour and the subtleties of the transitions. To achieve such digital enlargements without loss of quality requires exceptional printmaking skills. What the resulting images lose in intimacy, they gain in power and drama. These are gallery works that arrest the viewer and invite a kind of immersion in the world of colour, form and light that is impossible on a smaller scale.

YEAR ONE AND YEAR TWO

Before embarking on these large hybrid prints, though, Fabian Miller spent two years consolidating his practice using the remaining stored Cibachrome stock. From October 2005 to October 2006 he made a new image most days, a far higher rate of artistic production than he had ever achieved before. In that industrious year his output was over 300 prints, a series that he edited down to a core of 96. He grouped them by month of production, using the names of the Celtic calendar such as "Samonios" and "Dumannios". In *Year One*, as this series is known, each new print develops some aspect of the previous one. The result is a wide-ranging inter-linked exploration of the possibilities inherent in his self-chosen vocabulary. Beginning with a startling red eclipsed sun-shape against a black background, it moves through circles, grids, pink and red superimposed squares, back to pin-pricked circles, and then to blue rectangles, floating pale halos and moon-like emanations. Like Gerhard Richter's *Atlas*, (an album of newspaper clippings, photographs and sketches), Fabian Miller's *Year One* is a both an artistic work and an image bank from which further work can be inspired. Each of the 96 images could itself be the start of a new series. Taking his inspiration from the tradition of carrying cases used by Victorian art collectors Fabian Miller chose to house *Year One* in eight cube-shaped cabinets made of black walnut. Each cabinet contains 12 prints in its drawers, one from each month, thus recapitulating the year. Pictures can be removed individually or as a group to be displayed.

The intensity of the disciplined production of *Year One* led to a three-month break; then he returned to the darkroom for *Year Two*, which ran from January 2007 to December 2007, and from which many of the illustrations in this book were taken. In *Year Two* the months are named after minerals found in the Dartmoor soil, such as Arsenic and Feldspar. *Year Two* begins where *Year One* ended, with variations on moon-like discs. But soon it becomes more analytical and more rigorous. It is a systematic exploration of the possibilities of the square and the rectangle, with yellows and blues pre-dominating. Superficially this might have been a portfolio of Bauhaus experiments in abstraction, but in the context of Fabian Miller's oeuvre, it is a playing out of possibilities inherent in his earlier work and like *Year One* a rich resource for future art. Although each image stands alone as a completed piece, it is in sequence that they are best understood, as part of a developing narrative that can always be continued (usually in several different directions). The experience of looking at these works in this way can be like the gradual dawning awareness of a numerical sequence, appreciating the underlying relationships between different integers. Yet, to dwell too much in the formal world of patterns when coming to them, is to miss their essential connection to the light on the moors and the moments of domestic peace.

Fabian Miller's most recent work emerged from *Year One* and *Year Two*. The large-scale geometric and circular images of 2009 and early 2010 draw directly on these two sequences, building on the knowledge gained through the disciplined daily picture-making routine. The new work distills the places and light conditions that he explored in his two years of intense productivity. The larger scale forces a deliberate and slower rate of production on the artist, and invites a more intense and encompassing experience for the viewer, one more typical of the experience of abstract expressionist paintings than of photographs. As ever the purity and power of Fabian Miller's vision shines through.

When I visited Fabian Miller in January 2010 he had recently twice seen a rare phenomenon known as "The Spectre of the Brocken". This is the delicate rainbow-like aura around a walker's shadow sunlight can sometimes cast on mist. In these few moments the shape of a human body creates an ethereal image that transcends and transmutes ordinary perception. The intense beauty of this, which lasts just a few minutes, parallels what Fabian Miller alludes to in his pictures: moments of rarified perception that take you beyond the mundane, but which remain within the world of human beings, nature and light—the extraordinary in the everyday.

1 Conversation with Nigel Warburton, January 2010.
2 Quoted in Martin Barnes *Illumine: Photographs by Garry Fabian Miller—a Retrospective*, London: Merrell Publishers Ltd., 2005, p. 108.
3 Joyce, James, *Stephen Hero*, Panther Books, Granada Publishing Ltd, 1977, Chapter XXV, p. 190.
4 Conversation with Nigel Warburton, January 2010.

Garry Fabian Miller
Hayne Down, Dartmoor, April 2010
Copyright Victoria & Albert Museum, London

Above
Year One
2005–2006
Installation: Newlyn Art Gallery, Cornwall
February–April 2009

Opposite
Year One
2005–2006
Installation: New Art Centre,
Roche Court, Salisbury
December 2007–February 2008

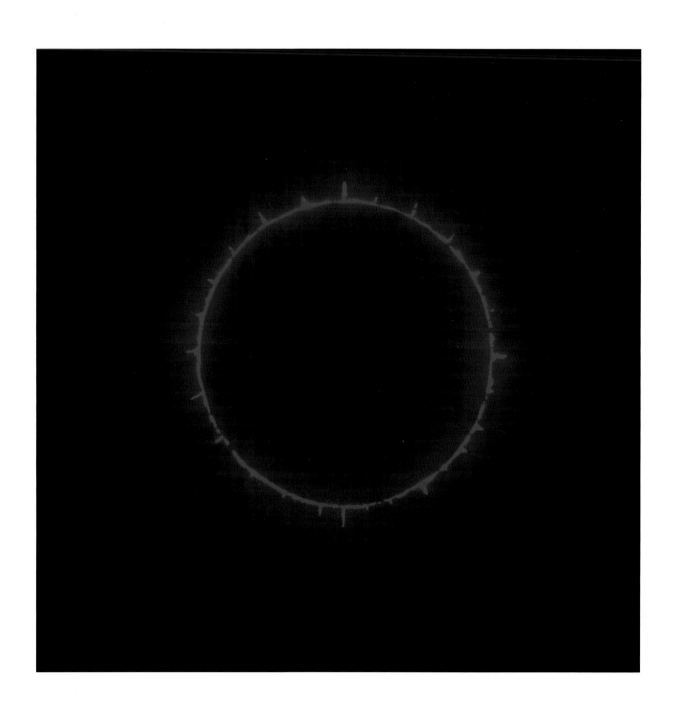

Year One, Samonios,
the seed fall
1. 2005
Water, light, dye destruction print
30.5 x 40.5 cm / 12 x 16˝ (detail)

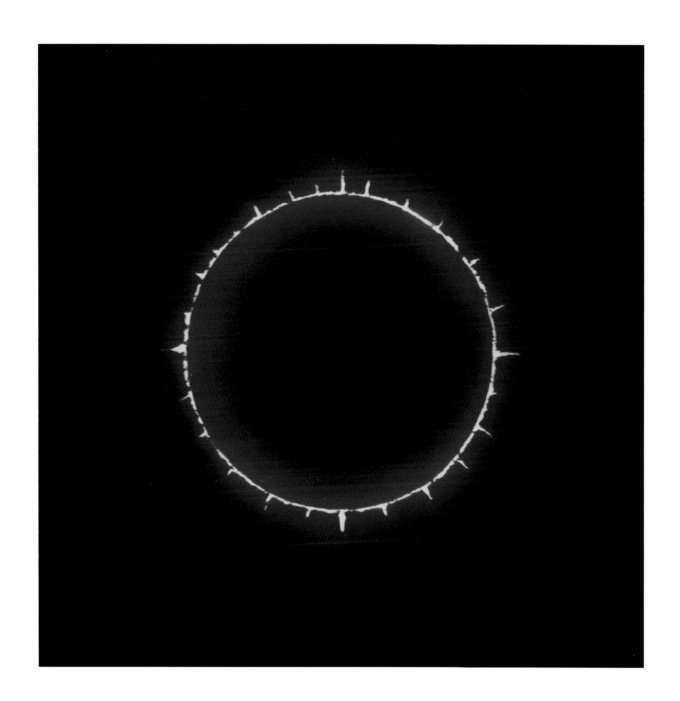

Year One, Samonios,
the seed fall
3. 2005
Oil, light, dye destruction print
30.5 x 40.5 cm / 12 x 16˝ (detail)

Year One, Dumanios,
the darkest depths
9. 2005
Oil, light, dye destruction print
30.5 x 40.5 cm / 12 x 16˝ (detail)

Year One, Riuros,
cold time
19. 2005
Oil, light, dye destruction print
40.5 x 40.5 cm / 16 x 16˝

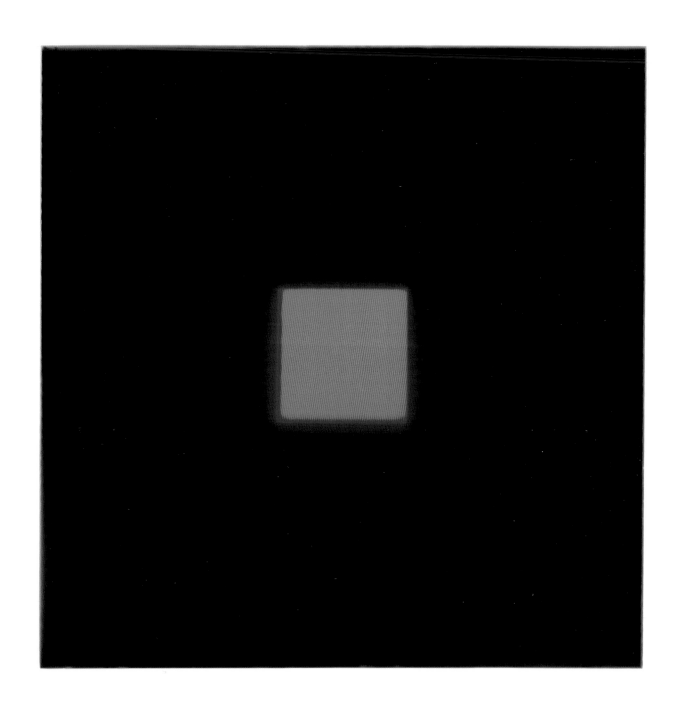

Year One, Anagantios,
hibernation

25. 2006

Water, light, dye destruction print

40.5 x 40.5 cm / 16 x 16˝

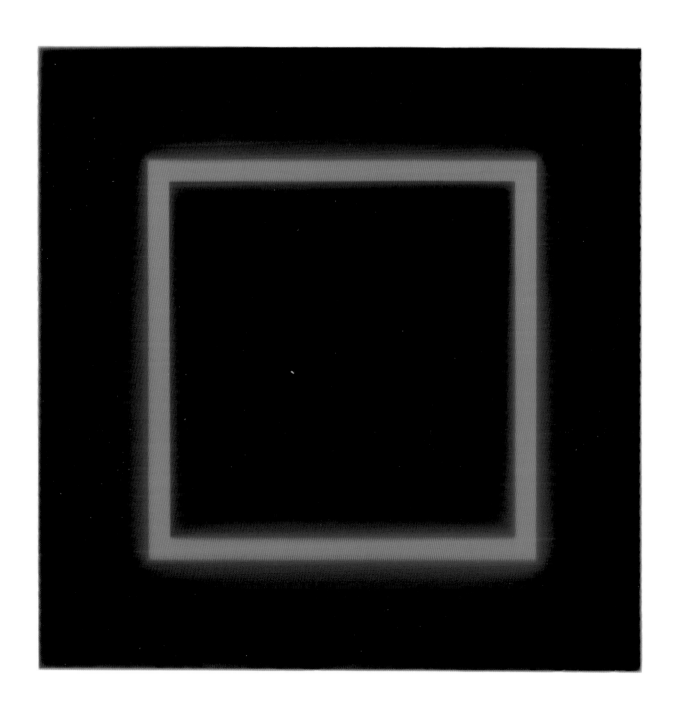

Year One, Orgronios,
the time of ice
33. 2006
Water, light, dye destruction print
40.5 x 40.5 cm / 16 x 16˝

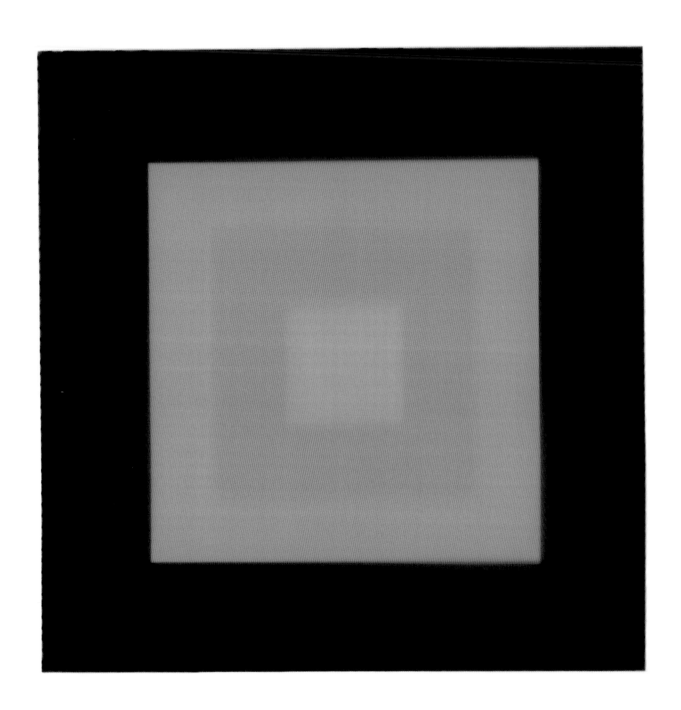

Year One, Cutios,
the time of winds
45. 2006
Water, light, dye destruction print
40.5 x 40.5 cm / 16 x 16˝

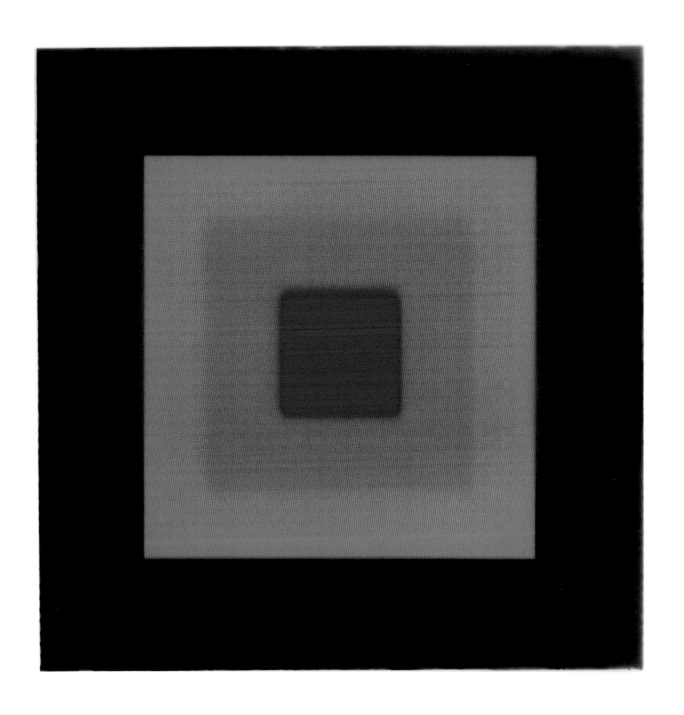

Year One, Cutios,
the time of winds
44. 2006
Water, light, dye destruction print
40.5 x 40.5 cm / 16 x 16˝

Year One, Giamonios,
shoots show
49. 2006
Water, light, dye destruction print
40.5 x 40.5 cm / 16 x 16˝

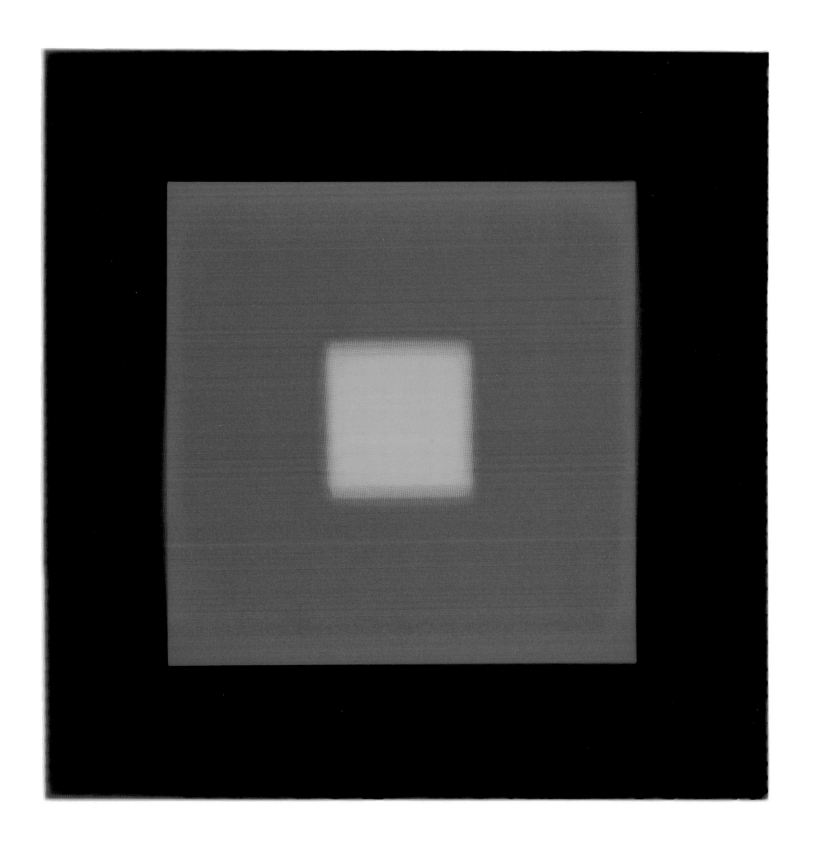

Year One, Simivisionios,
the time of brightness
59. 2006
Oil, light, dye destruction print
40.5 x 50.5 cm / 16 x 20˝

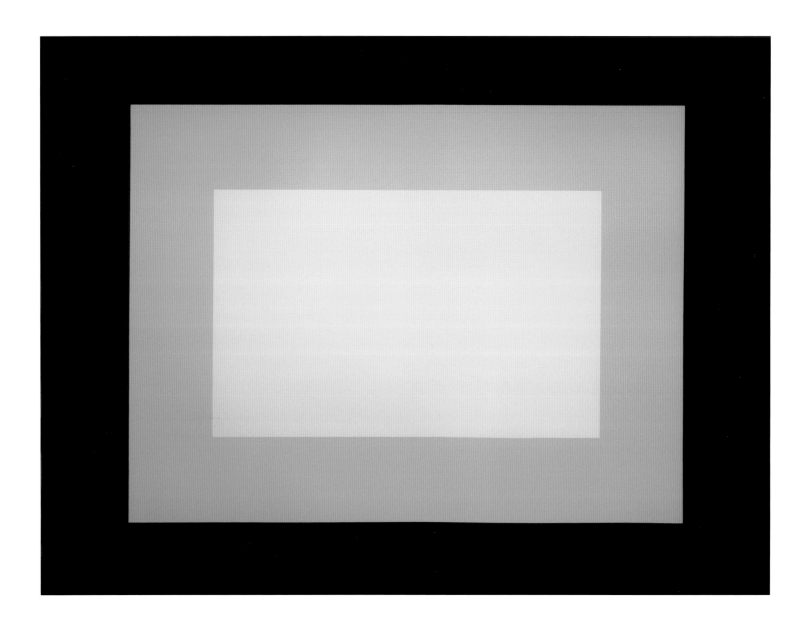

Year One, Equos,
horsetime

71. 2006
Water, light, dye destruction print
40.5 x 50.5 cm / 16 x 20˝

Year One, Equos,
horsetime
65. 2006
Water, light, dye destruction print
40.5 x 50.5 cm / 16 x 20″

Year One, Elembiuos,
harvest
77. 2006
Water, light, dye destruction print
50.5 x 40.5 cm / 20 x 16˝

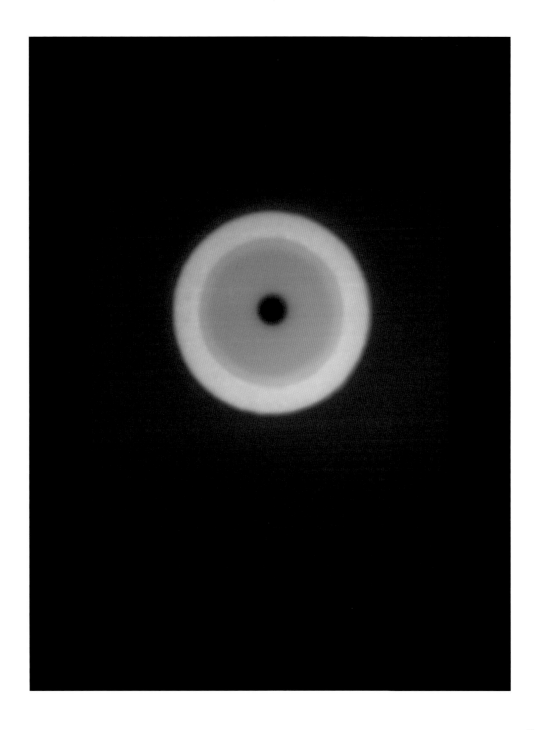

Year One, Edrinios,
the sharing time
88. 2006
Water, light, dye destruction print
50.5 x 40.5 cm / 20 x 16˝

Year One, Cantios,
song time
91. 2006
Water, light, dye destruction print
50.5 x 40.5 cm / 20 x 16˝

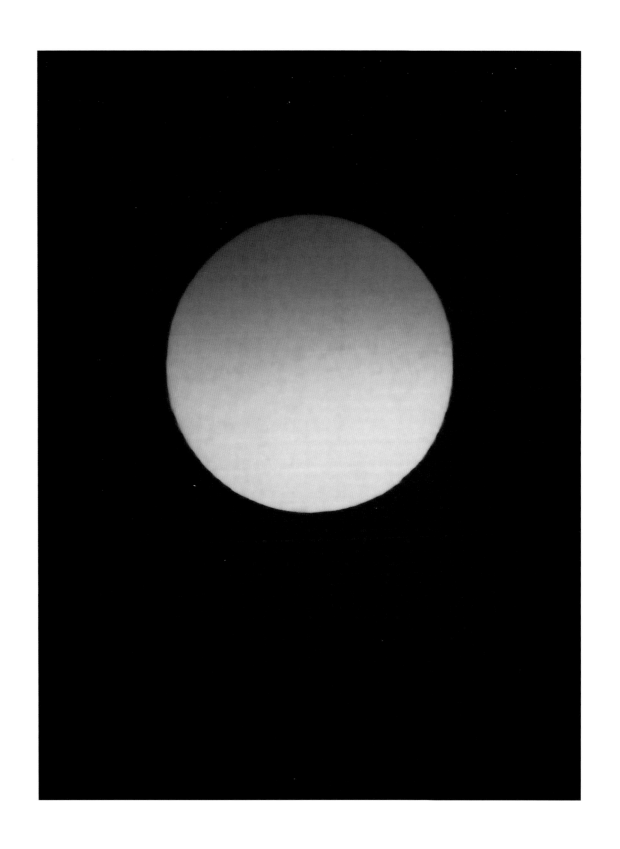

ADYNATA— TIME'S COLOUR; IMPOSSIBLE BEAUTY

MARINA WARNER

ONE

The princess in the fairy tale *Donkey-Skin* asks her father for *une robe qui soit de la couleur du temps*—a dress the colour of time: her demand is a ruse to baffle him, to test him beyond his limits. But in a trice, even before the next dawn has broken, he has the palace tailors and dressmakers conjure up one for her:

> *Le plus beau bleu de l'Empyrée*
> *N'est pas, lorsqu'il est ceint de gros nuages d'or,*
> *D'une couleur plus azurée.*[1]

The author, Charles Perrault, is reaching for superlatives as he struggles to express the ineffability of the enchantment; and while imagination can raise the image in the mind's eye, language can only limp after it, just as it stumbles to communicate colour *per se*: my green may not be your green, neither the colour of what you see with your eyes nor the colour your culture calls by that name.[2]

Colour is experience that escapes representations in any other form but itself: though a paint chart strives towards a sensuous vocabulary of precise discriminations or encodes a variety of shades in a string of numbers, colour itself has to be seen for itself. It can be packed with symbolism, but cannot itself be symbolised; it can only be the thing itself. You cannot deduce the colour of turquoise or indigo from context, as you can grasp what "slenderness" or "roughness" or "piping hot" or "uphill" means. Colour has coordinates, so you can try to explain that porphyry, for example, lies between purple and dark red; or that tangerine stands closer to orange than to scarlet. One colour may adjoin another on the spectrum but its distinctiveness is often culturally determined: Newton numbered and defined as seven the colours in the rainbow in a spirit of Pythagorean idealism, so that the spectrum would correspond harmoniously to the musical scale. For some peoples green is a kind of brown, for others, a kind of blue; in some languages there are no words for

certain colours (Welsh has no equivalent words for English green, blue, grey or brown but *glas* covers part of green with other terms dealing with other greens, etc.); the ancient languages are strikingly poor in terms: a scant five are the norm.[3] Language, you could say, is a country of the mostly colour-blind.

By contrast, art is rich in scope and artists' materials exist in light, colour's prerequisite. When the princess turns to her fairy godmother in despair that her father has produced the dress the colour of time and by this means is continuing to insist on marrying her that very day, the fairy advises the princess to ask next for a dress the colour of the moon—another form of light itself. When this dress too proves a trifling matter for him to create for her, she then reaches for another, even more extraordinary gift—a dress the colour of the sun. Again, he has one made for her.

Although the dramatic fantasies of fairy tale lie very far from the intense meditative abstraction of Garry Fabian Miller's work, the imagery in *Donkey-Skin* offers, it seems to me, a way of thinking about what the artist photographer is unfolding before our eyes. For the colour of time also foreshadows its sequels in the story: time here encloses the idea of the colour of the moon and of the sun, phenomena which likewise can't be caught and spun and woven into a single stretch of fabric. They are light itself, the sources by night and day, never stable but always in motion, and their colour can't be understood except over time. In *Year Two*, Garry Fabian Miller has suspended orbs of mysterious blue against a dark field like new moons on a clear night far from urban light pollution; in others of the sequence, he has caught the luminescent sprue of pink magenta as it spills over the edge between ultramarine and deep red-brown like the gilded, luminous line at the horizon, which reveals the sun's presence below it.

His daily experiments capture the unfolding of light over hours or even days by prolonging the exposures and then producing an image that condenses all that cosmic circling and burning into a steady state on the paper, on the wall. Yet, even while stilled into a photograph, the image pulsates from the intensity of the illumination that went into its making.

Such pictures belong to the history of attempts to picture the cosmos, and can be usefully compared to astrological illuminations and to speculative meteorology: the world burn as imagined by Heraclitus and the Neoplatonists. Roger Fludd pictured the origins of the world in his book, *Utriusque Cosmi*, 1619, as a sphere flaming out of a black void; Thomas Wright, in another magnificently illustrated cosmology (1750) imagined a multitude of heavenly bodies in overlapping density, and gave each of them an eye looking back at us out of "the endless Immensity... an unlimited Plenum of creations...".[4]

Garry Fabian Miller's works reach beyond conceivable phenomena and beyond palpable experience, to represent the appearance of time and seize duration in the silent and motionless confines of a photographic image. With patient vigilance in the studio, he is turning time into images and light into artefacts; he is receiving the lapse of time and returning it as colour. The works register hue and brilliance, but above all saturation, the third aspect of colour's visibility, transforms them into tels of time, archaeology extended onto a surface that, on account of that saturation, has been turned into depths.

It seems to me that this artist's absorptive attention to capturing light as it fills space-time corresponds to the hero's task of obtaining the oxymoronic, impossible object.

Opposite
Year Two, Arsenic 1
January 2007
Water, light, dye destruction print
50.5 x 40.5 cm / 20 x 16˝

TWO

Fairy tales and myths often quest for impossible things. Sometimes heroes and heroines must obtain them in order to save their own lives or achieve their goal: their taskmaster, often a witch or wicked stepmother, tells them to fetch water in a sieve, to fill a basket of strawberries in the snow. Psyche is one of the earliest put-upon questors in this fashion: she has to descend into the Underworld to fetch back a beauty ointment for her mother-in-law, Venus.

The expectation is that the goal will prove unattainable and the young hero or heroine will fail: Venus wishes Psyche ill and doesn't think she'll come back from Hell. But romances and fairy tales reverse that ordinary outcome—the tale reconciles the impossible with the possible, and the ending, which becomes all the more satisfying because it squares the circle, conjoins contradictions, overcomes paradox. By means of word magic, images which have no existence in reality—a dress the colour of time, strawberries in the snow—have come into being. William Blake made up a song about such paradoxical quests which begins:

Go and catch a falling star
Get with child a mandrake root...

Reversing the direction of the pursuit, Blake also drew a small figure on a ladder climbing towards the moon, and crying out "I want, I want." In this watercolour, desire, even though desperate, begins to turn funny and whimsical.

Adynaton is the technical word for the figure of speech that sets out such impossible tasks or objects, and it is defined in the handbooks as a form of wild exaggeration or hyperbole. But adynata are more mysterious than that: they contain non-sense in its most koanic or mystical form, holding opposites in harmony. Adynata include, for instance, the tantalising riddling figures of folklore, such as those that are braided through the beautiful ballad, sung to the tune of "Scarborough Fair":

Can you make me a cambric shirt
 Parsley, sage, rosemary, and thyme,
Without any seam or needlework?
 And you shall be a true lover of mine.[5]

The lover then goes on to ask his girl to wash the shirt in a well where no water ever fell, and dry it on a thornbush that has never flowered (in this sense it has never been). To this challenge, she replies by setting him another sequence of requests that confound all logic:

Can you find me an acre of land
 Parsley, sage, rosemary, and thyme,
Between the salt water and the sea sand?
 And you shall be a true lover of mine.

Their duet is a kind of flyting, or battle of wits, a form of flirting and wooing that takes pleasure in the contest. She sings that he must sow this stretch of land with a

single peppercorn, reap it with a sickle of leather, "and bind it all up in a peacock's feather". Then and only then, can he come to her for his shirt: "And you shall be a true lover of mine."

The song of the cambric shirt, in one version published around 1670, has been attributed to King James I; in this one the girl, asked to make the impossible garment, retorts with some different, wonderfully fanciful demands of her own about the growing and gathering of the flax from which, if it is forthcoming, she will make it:

> 'Thou must barn it in a mouse-holl,
> And thrash it into thy shoes soll.[6]

But the song is very old, so old its origins aren't known, but are guessed to be oriental. In Persian and Arabic literature, the same puzzling conundra appear and heighten the romantic intensity of a love story. In *The Dream of the Red Pavilion*, the beloved is so accomplished at painting and calligraphy that she can draw pictures on water.[7]

THREE

The phrase *couleur du Temps* from *Donkey-Skin* means that the dress in question is blue—the phrase corresponds to "the colour of the heavens", or, sometimes, "the colour of the sky".[8] Time here becomes sky: the blue yonder of space vaulted overhead expresses, according to the logic of imagination and experience, another kind of length and distance, of the past and of the future. But *temps* also means weather: the fourth dimension requires that an artist turn to meteorology, another science which, like alchemy, has affinities with photography, and was once closely allied with magical arts, such as scrying and divination.

In the 70s, in his first sequence of photographs made when he was 19, Garry Fabian Miller chronicled the changing light every evening out of his window over the Severn estuary. He was using a camera then; soon the camera would be set aside. Now, three decades and many hours of patient invigilation later, the artist no longer takes subjects on which the light plays—no sea or window pane, leaf or flower bud. He has commented that, rather like the photosynthesising leaves which he photographed in the 80s and 90s, he now acts in the manner of a plant himself, taking in the light by walking in the landscape around his Devon home and in its garden and woods. By adopting this receptive routine, he prepares the way to making the images: "all the things inside my head come from all the things which have come through my eyes.... Everything in the pictures I believe I have already seen, or they're things which I've yet to see. The walking and the daily activities somehow create the space where these things are going to become visible."[9] He is now making images of cast light itself, colour as it radiates, undulates, quivers, and falls.

In a recent study, *Seeing Dark Things*, the analytic philosopher Roy Sorensen responds to a question put by the philosopher GE Moore at the time of the arrival of cinema: "What is this thing thrown on the screen in the cinema?" He did not provide a reply—at least not fully. Picking up on Moore, Sorensen proposes, by analogy with "shadow", a new term—"filtow"—to describe a cast image through which light is filtered. It's not a shadow, because a shadow is made by an object blocking the ray of light, but rather a filtered radiance, such as the luminous figure created by the light

Homeland, artist's garden

passing through a stained glass window. In religious symbolism, the virgin birth—another enigma, another impossible wonder—generated series of riddling images; and in one of them, St Bernard likened Christ's miraculous birth to a sunbeam passing through a pane of glass.

The filtow corresponds to one of the most sacred forms of image, the spontaneous icon, such as the face of Christ himself that appears on the cloth when Veronica wipes it on the road to Calvary, and finds that his features are imprinted on the cloth. These miraculous icons are called *acheiropoieta*—images made without hands. Photography in its earliest phase was recognised as partaking of this sacred and wonderful state: Fox Talbot absented himself as author from his experiments when he called the new artefacts "sun-drawings" and "sciagraphs" (writing in shadows). Martin Barnes has recognised how the new generation of artists who are working without the mediation of a camera or lens are developing the natural magic at the origin of photography itself: the natural magic of light's actions.[10] Garry Fabian Miller's art, leaving the light to do its work over certain periods of time in the dark room on its own, moves as close to the autonomous wonder of the *acheiropoieton* as is possible for an artist. "I'd quite like to be invisible", he says.

John Clare, a poet of sights and sounds whose sensibility for the loveliness of natural things makes him one of Garry Fabian Miller's precursors, wrote synaesthetically about the light and its beauty:

But love delightful seems.

'Tis seen in flowers,
And in the morning's pearly dew;
In earth's green hours,
And in the heaven's eternal blue.

'Tis heard in spring
When light and sunbeams, warm and kind
On angel's wing
Bring love and music to the mind.

Garry Fabian Miller has also brought images from flowers and angels into his work in the past and translated his studies of the light into metaphors for ideals out there: he called haloes "Angels" and found symbols in the lunar spheres of the seedpods of Honesty, in the cruciform silhouettes of the Petworth windows; he looked for eternal meanings and ideals that art could record and pass on. Now, he feels "in a post-Lovelock state", and wants his pictures "to embody the place that might exist after we have destroyed this one". He reaches out towards the elements in their flux and flow and radiance: to find the flame, the aureole, the wave, and make visible the physical forces of the natural world which we can't feel and cannot see except partially, through a glass darkly.

Foxglove
10 August 1990, Homeland
Flower, light, dye destruction print
41 x 41 cm / 16 x 16" (detail)

FOUR

The *acheiropoieton* is not only made without hands (almost); these images can only be themselves, seen for themselves—ekphrasis cannot render them any more than the words for reds and blues and yellows, however resonant they are, will tell someone else what those reds and blues and yellows are or will be able to tell you afterwards how to reconstruct what they looked like at the time. The opus creates its own weather, its own colours of time. It's an interior weather made visible, and it confronts us, looking at the images, with the incommensurability of experience and representations, linguistic and symbolic. When I enter the gravitational field of Garry Fabian Miller's images, at first I can keep hold of familiar coordinates, as I keep recognising the phenomena through language and visual memories. But all the gorgeous chromatic lexicon of the blues—indigo, ultramarine, cobalt, lapis lazuli, cerulean, cyan, porphyry, azure; all the blazing glory of the reds and yellows—scarlet, cinnabar, crimson, ruby, saffron, jasper, and orpiment—fall away before the thing itself, the unfurled depths and subtlety of luminous colour as it happens for real in the artist's adynaton, the light-writing of time, sun, and moon.

1 Perrault, Charles, *Peau d'âne*, in *Contes de Perrault*, ed. G Rouger, Garnier: Paris, 1967, pp. 57–75;
 "… its sheer and splendid azure hue
 Outshone the sky's most glorious blue
 When clouds are strewn across it golden bright."
 Christopher Betts, *Donkey-Skin*, a new translation of Charles Perrault, *The Complete Fairy Tales*, Oxford: Oxford University Press, 2009, pp. 52–73: 60.

2 See John Gage, "Colour and Culture", and John Lyons, "Colour in language", in *Colour: Art & Science*, ed. Trevor Lamb and Janine Bourriau, Cambridge: Cambridge University Press, 1995, pp. 175–193, 194–224.

3 Lyons, "Colour in language", in *Colour: Art & Science*, p. 200.

4 Wright, Thomas, *An Original Theory or New Hypothesis or the Universe*, 1750, Pl. XXXII, reproduced in Martin Schonfield, "The Phoenix of Nature: Kant and the Big Bounce", in *Collapse: Philosophical Research and Development*, Falmouth, Vol V, 2009, pp. 361–376, p. 384.

5 Opie, Iona and Peter, eds. *The Oxford Dictionary of Nursery Rhymes*, Oxford: Oxford University Press, 1977, pp. 108–111: 108.

6 Opie, *The Oxford Dictionary of Nursery Rhymes*, p. 110.

7 Nezami, *Le Pavillon des sept princesses*, trans. Michael Barry, Paris: Gallimard, 2000, p. 307.

8 The analogy the editors offer comes from another fairy tale, *L'Oiseau bleu* (*The Blue Bird*) by Marie Catherine d'Aulnoy from the same period, the late seventeenth century, when the princess in that story calls to her beloved, who has been changed into a parrot:
 "*L'Oiseau bleu, couleur du temps
 Vole à moi promptement.*"

9 The artist in conversation with Martin Barnes, 28 November 2009, during Garry Fabian Miller—The Colours, Ingleby Gallery, Edinburgh.

10 Barnes, Martin, "Light/The Visible Reminder of the Invisible", catalogue essay, Graves Art Gallery, 17 August–12 October 2002.

Petworth Window
14 May 2000
Water, light, dye destruction print
94 x 85 cm / 37 x 32½″

YEAR
TWO

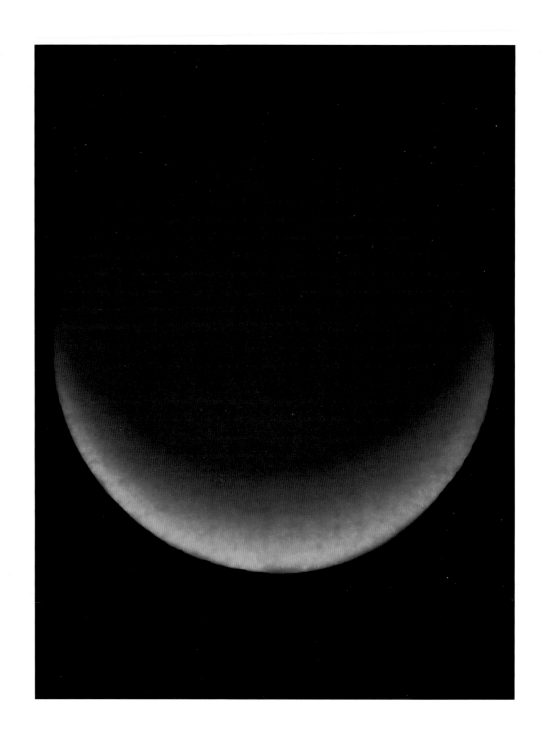

Year Two, Arsenic 6
January 2007
Water, light, dye destruction print
50.5 x 40.5 cm / 20 x 16˝

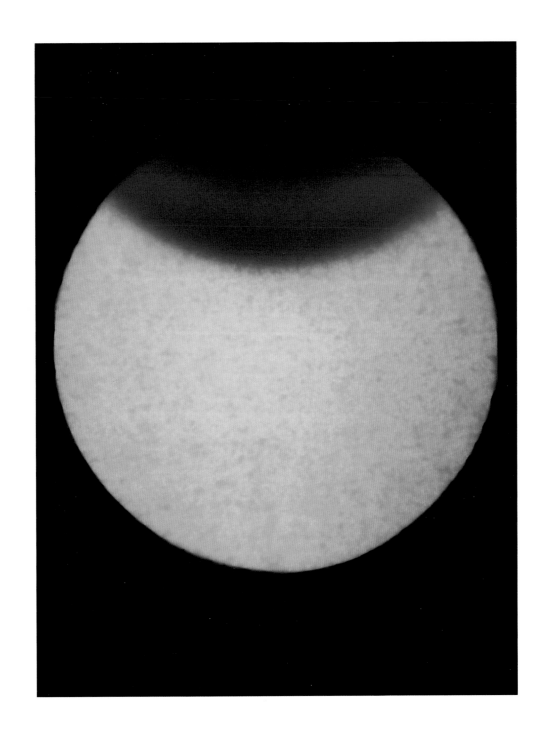

Year Two, Arsenic 9
January 2007
Water, light, dye destruction print
50.5 x 40.5 cm / 20 x 16˝

Year Two, Arsenic, 1–10
January 2007
Water, light, dye destruction print
50.5 x 40.5 cm / 20 x 16˝ (each work)

Year Two, Quartz 9
February 2007
Oil, light, dye destruction print
40.5 x 50.5 cm / 16 x 20˝

Year Two, Quartz 4
February 2007
Oil, light, dye destruction print
40.5 x 50.5 cm / 16 x 20″

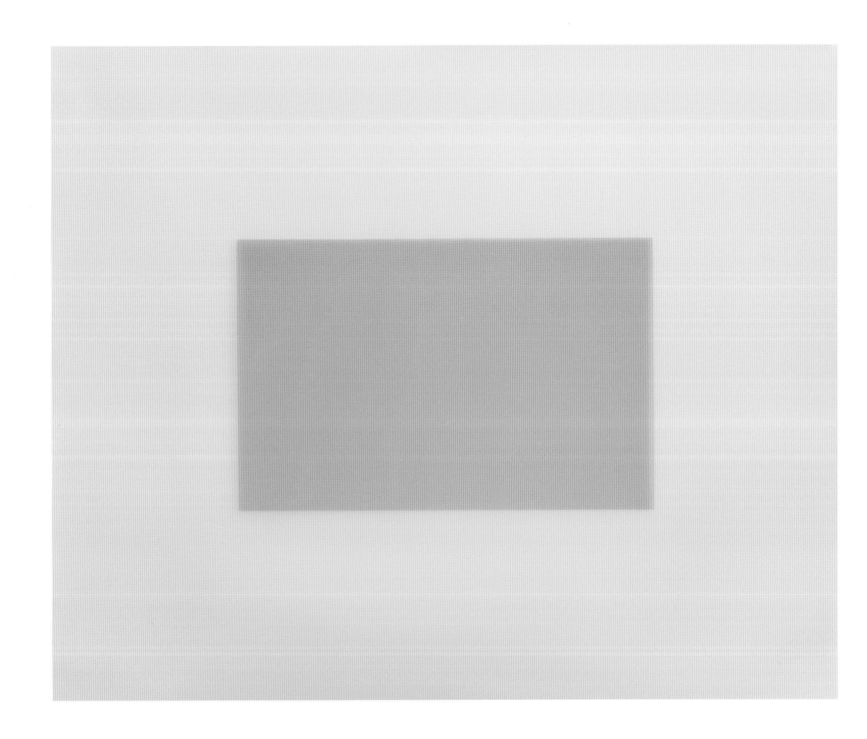

Year Two, Quartz 6
February 2007
Oil, light, dye destruction print
40.5 x 50.5 cm / 16 x 20˝

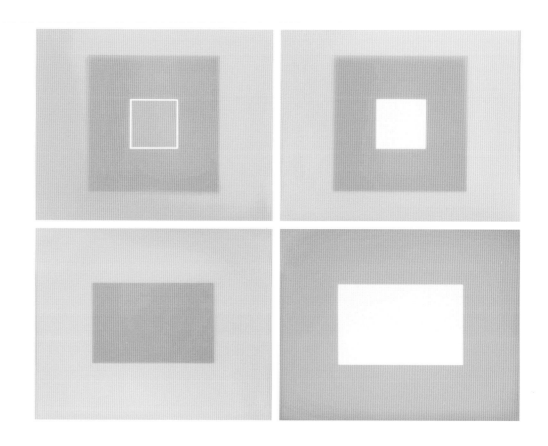

Year Two, Quartz 1–10
February 2007
Oil, light, dye destruction print
40.5 x 50.5 cm / 16 x 20˝ (each work)

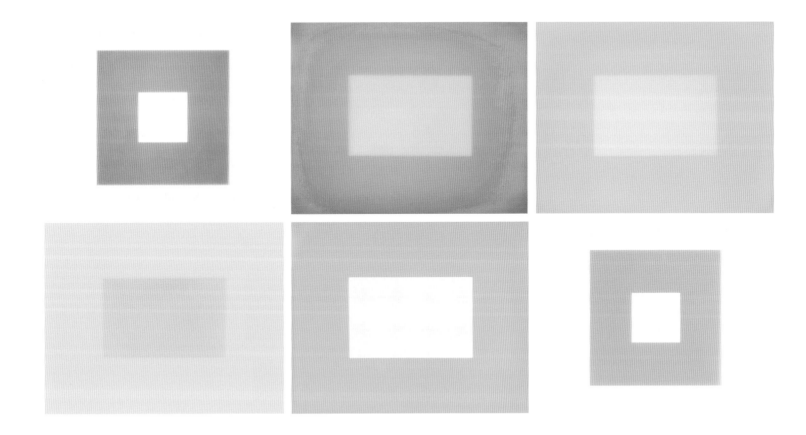

Year Two, Gold 1
March 2007
Oil, light, dye destruction print
50.5 x 40.5 cm / 20 x 16˝

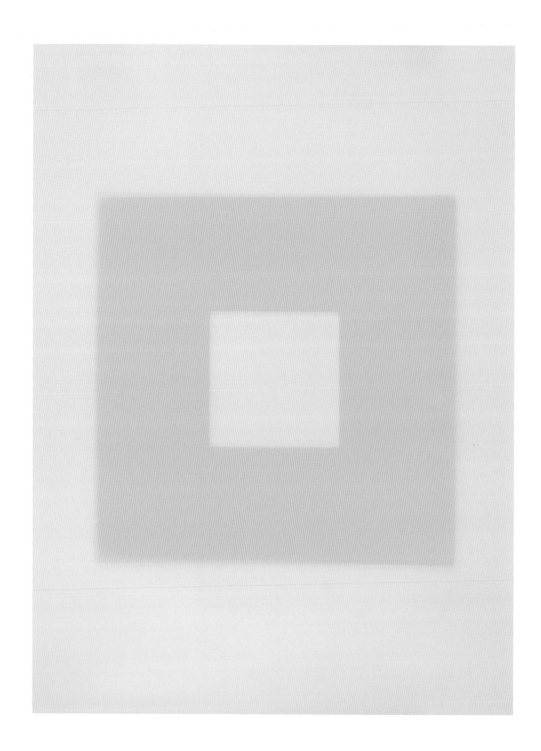

Year Two, Gold 3
March 2007
Oil, light, dye destruction print
50.5 x 40.5 cm / 20 x 16˝

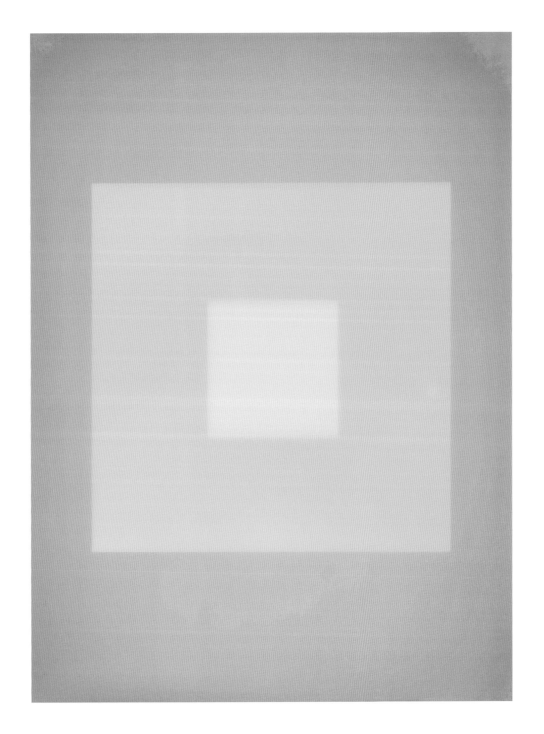

Year Two, Gold 5
March 2007
Oil, light, dye destruction print
50.5 x 40.5 cm / 20 x 16˝

Year Two, Gold 9
March 2007
Oil, light, dye destruction print
50.5 x 40.5 cm / 20 x 16˝

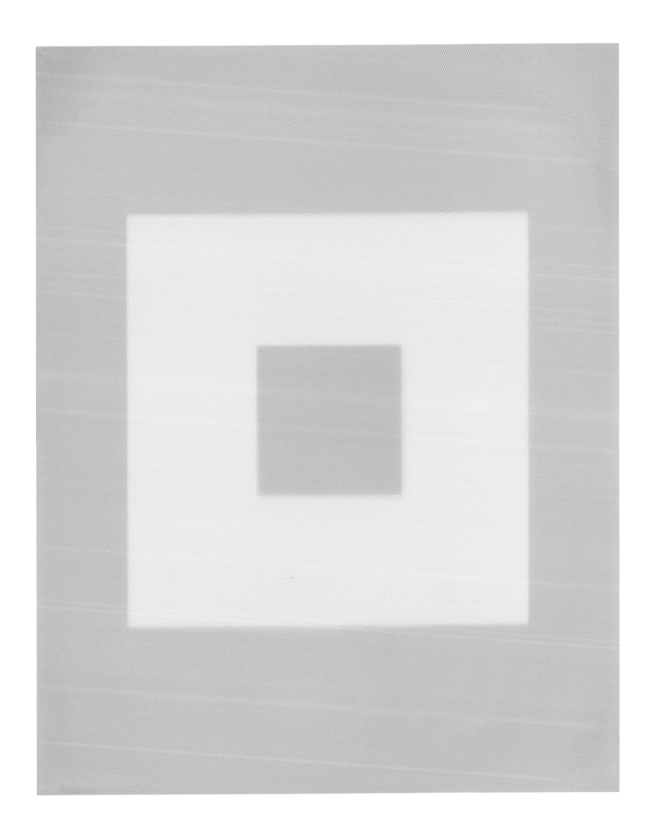

Year Two, Gold 10
March 2007
Oil, light, dye destruction print
50.5 x 40.5 cm / 20 x 16˝

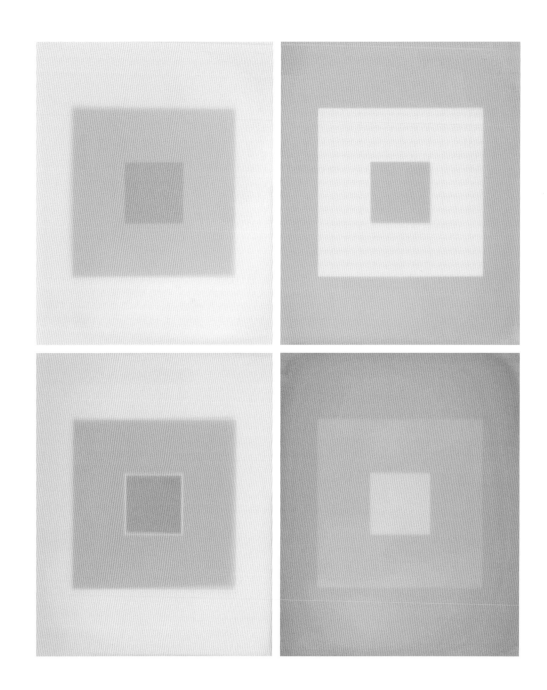

Year Two, Gold 1–10
March 2007
Oil, light, dye destruction print
50.5 x 40.5 cm / 20 x 16˝ (each work)

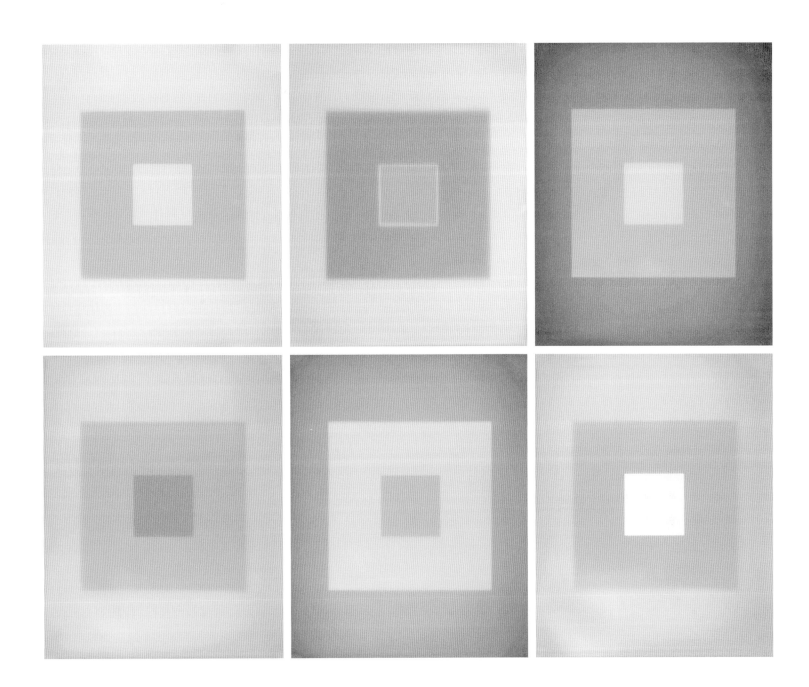

Year Two, Silicate 1–2
April 2007
Oil, light, dye destruction print
50.5 x 82 cm / 20 x 32½"

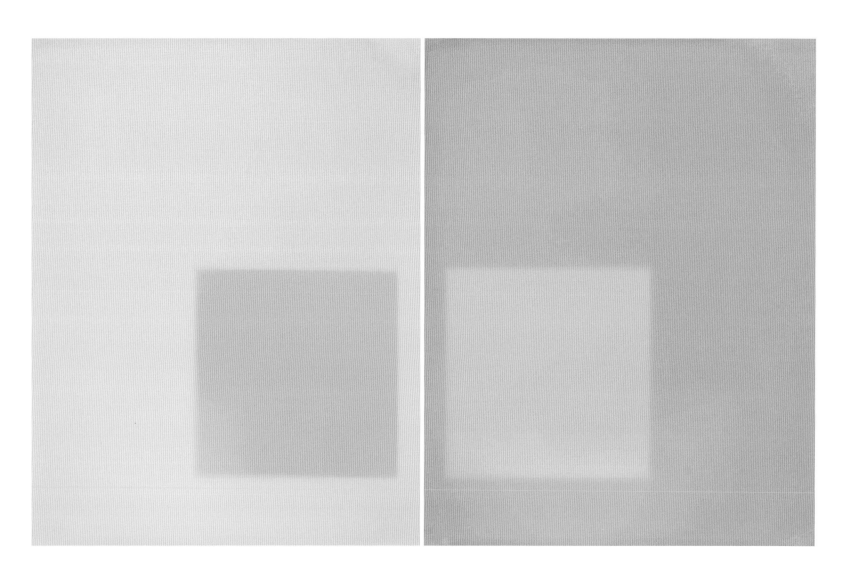

Year Two, Silicate 3–4
April 2007
Oil, light, dye destruction print
50.5 x 82 cm / 20 x 32½"

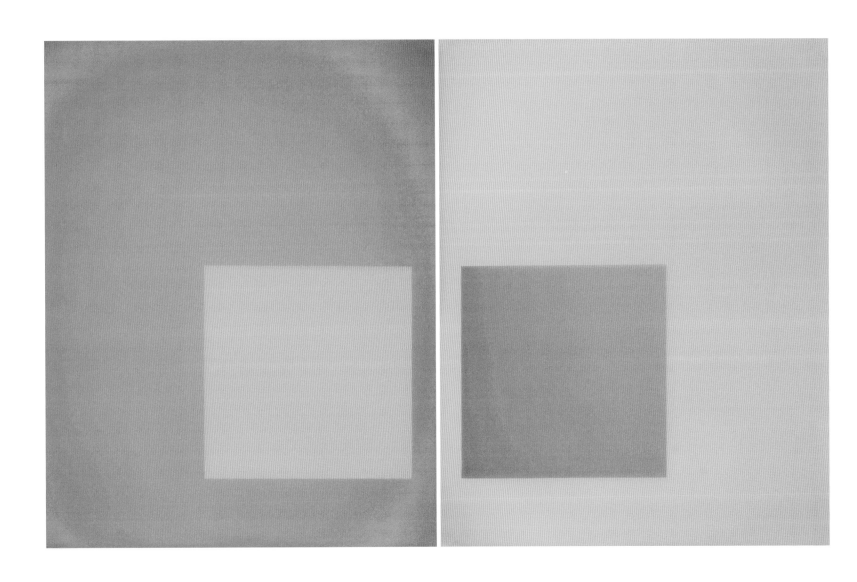

Year Two, Silicate 7–8
April 2007
Oil, light, dye destruction print
50.5 x 82 cm / 20 x 32½″

Year Two, Silicate 9–10
April 2007
Oil, light, dye destruction print
50.5 x 82 cm / 20 x 32½˝

Year Two, Silicate 5–6
April 2007
Oil, light, dye destruction print
50.5 x 82 cm / 20 x 32½"

Year Two, Mica 1
May 2007
Oil, light, dye destruction print
40.5 x 50.5 cm / 16 x 20˝ (detail)

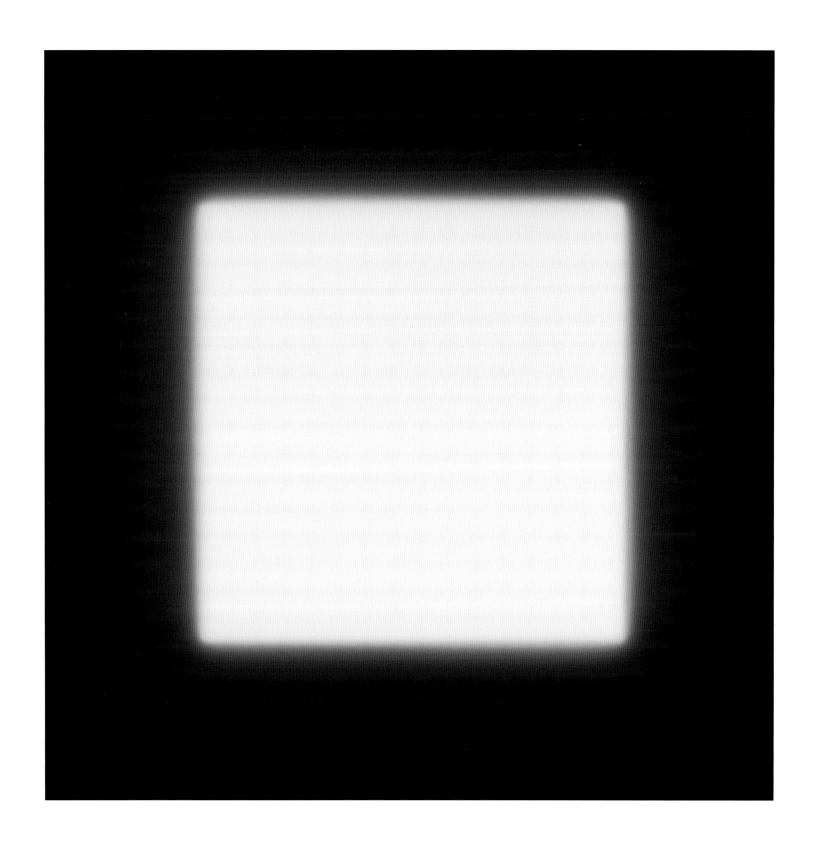

Year Two, Mica 4
May 2007
Oil, light, dye destruction print
40.5 x 50.5 cm / 16 x 20˝ (detail)

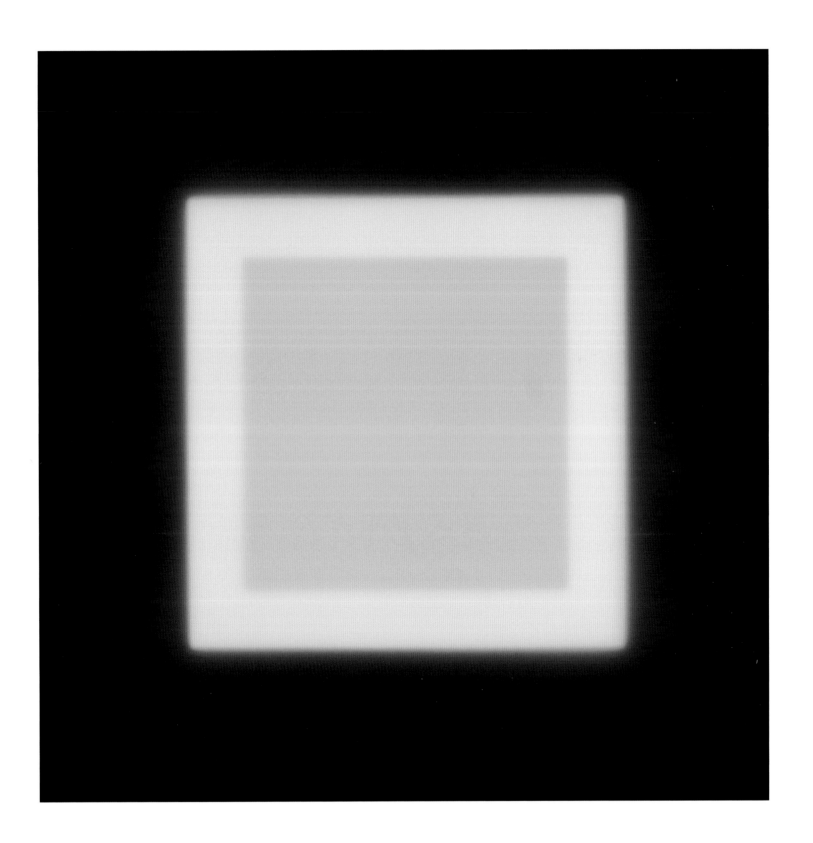

Year Two, Mica 7
May 2007
Oil, light, dye destruction print
40.5 x 50.5 cm / 16 x 20˝ (detail)

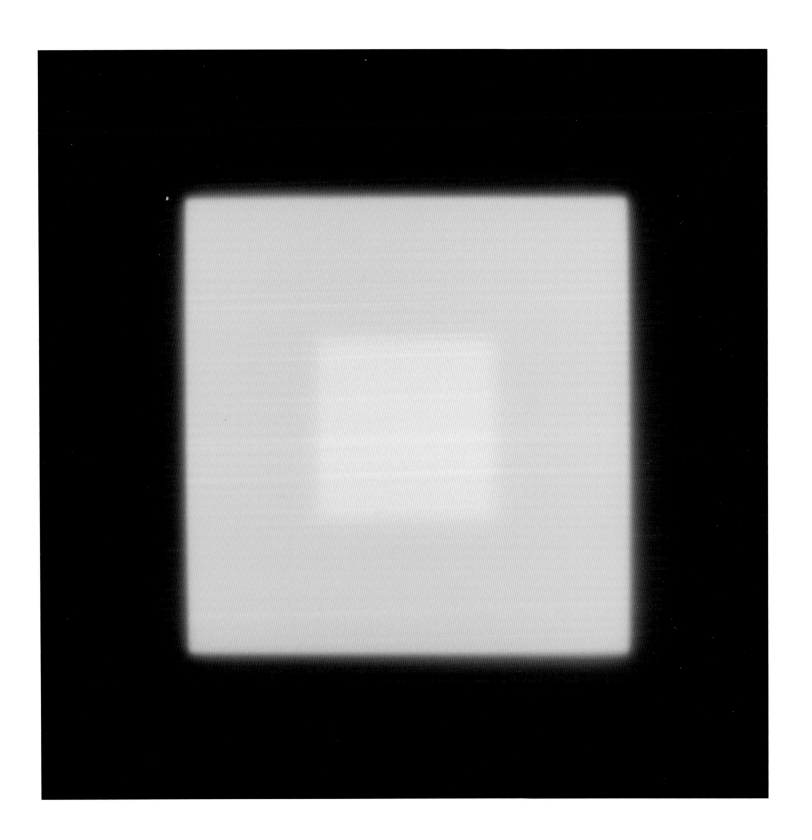

Year Two, Mica 10
May 2007
Oil, light, dye destruction print
40.5 x 50.5 cm / 16 x 20˝ (detail)

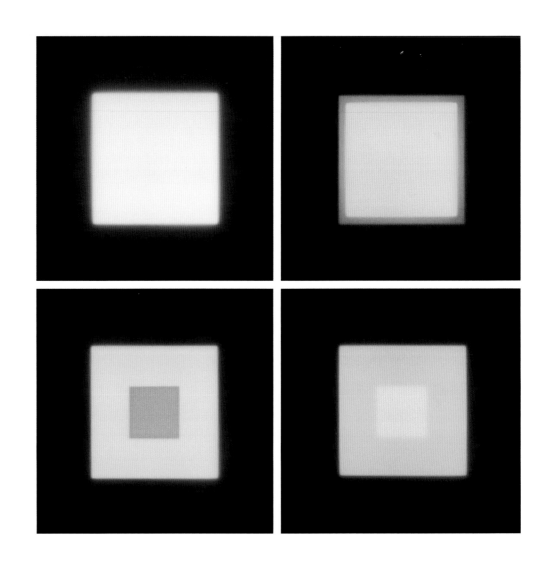

Year Two, Mica 1–10
May 2007
Oil, light, dye destruction print
40.5 x 50.5 cm / 16 x 20˝ (each work, detail)

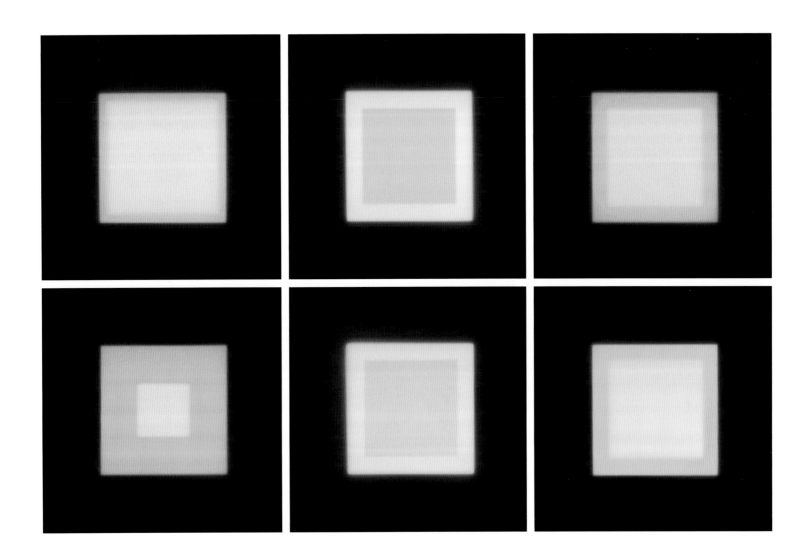

Year Two, Growen 3
June 2007
Oil, light, dye destruction print
50.5 x 40.5 cm / 20 x 16˝

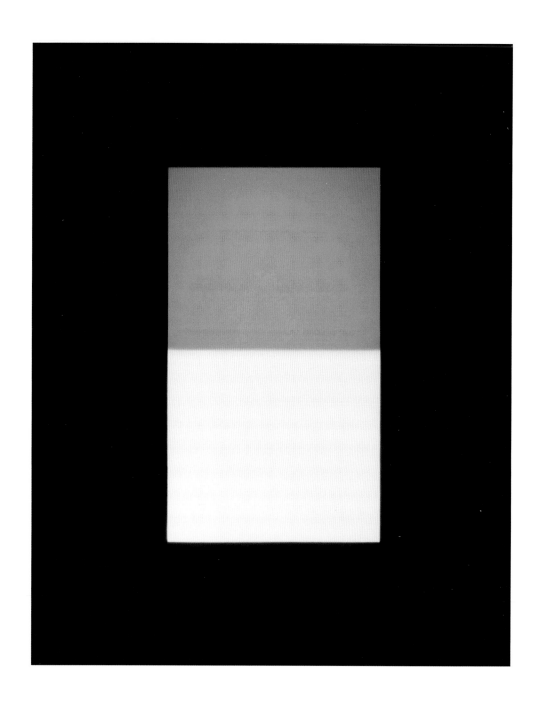

Year Two, Growen 1
June 2007
Oil, light, dye destruction print
50.5 x 40.5 cm / 20 x 16˝

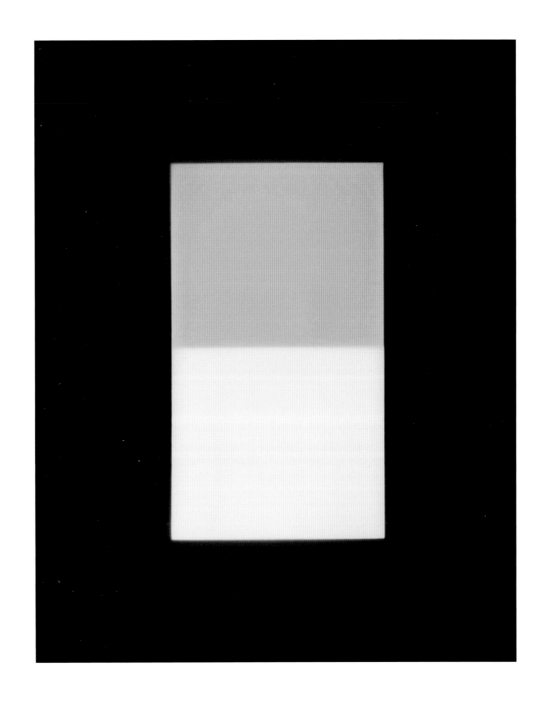

Year Two, Growen 7
June 2007
Oil, light, dye destruction print
50.5 x 40.5 cm / 20 x 16˝

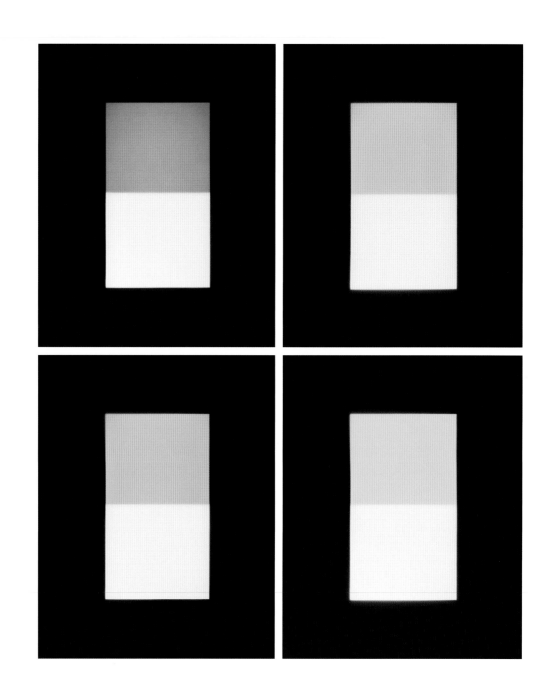

Year Two, Growen 1–10
June 2007
Oil, light, dye destruction print
50.5 x 40.5 cm / 20 x 16″ (each work)

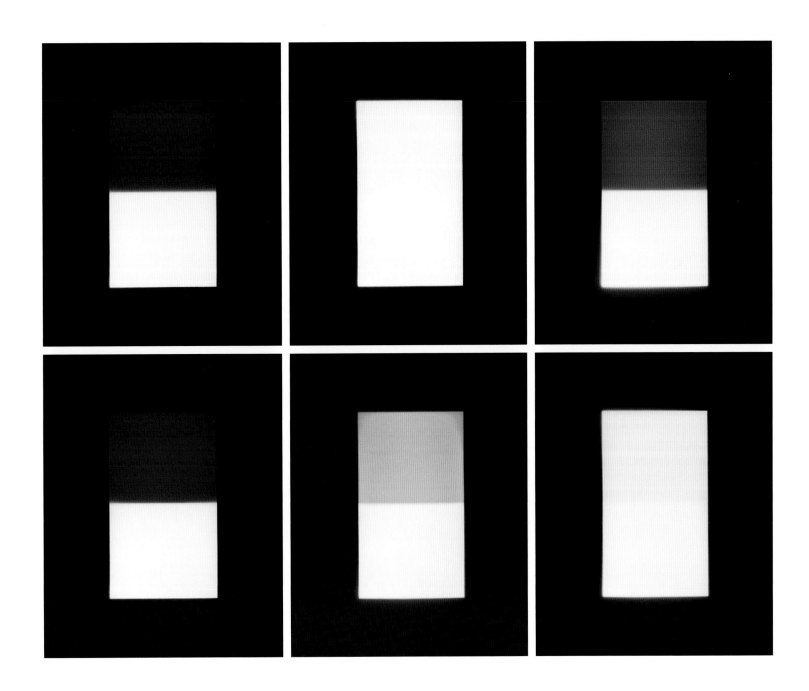

Opposite and overleaf (detail)
Year Two, Feldspar 1
July 2007
Oil, light, dye destruction print
202.5 x 50.5 cm / 80 x 20"

Opposite and overleaf (detail)

Year Two, Tungsten 1

August 2007

Water, light, dye destruction print

202.5 x 50.5 cm / 80 x 20˝

Year Two, Cobolt 3
September 2007
Oil, water, light, dye destruction print
40.5 x 50.5 cm / 16 x 20˝

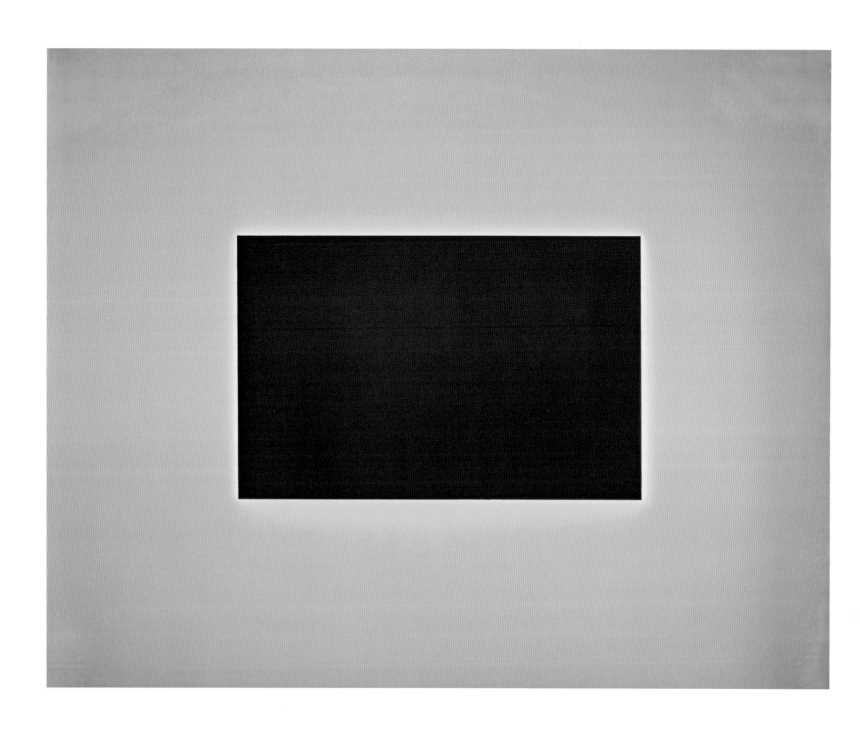

Year Two, Cobolt 2
September 2007
Oil, water, light, dye destruction print
40.5 x 50.5 cm / 16 x 20˝

Year Two, Cobolt 4
September 2007
Oil, water, light, dye destruction print
40.5 x 50.5 cm / 16 x 20˝

Year Two, Cobolt 6
September 2007
Oil, water, light, dye destruction print
40.5 x 50.5 cm / 16 x 20˝

Year Two, Cobolt 9
September 2007
Oil, water, light, dye destruction print
40.5 x 50.5 cm / 16 x 20˝

Year Two, Cobolt 10
September 2007
Oil, water, light, dye destruction print
40.5 x 50.5 cm / 16 x 20˝

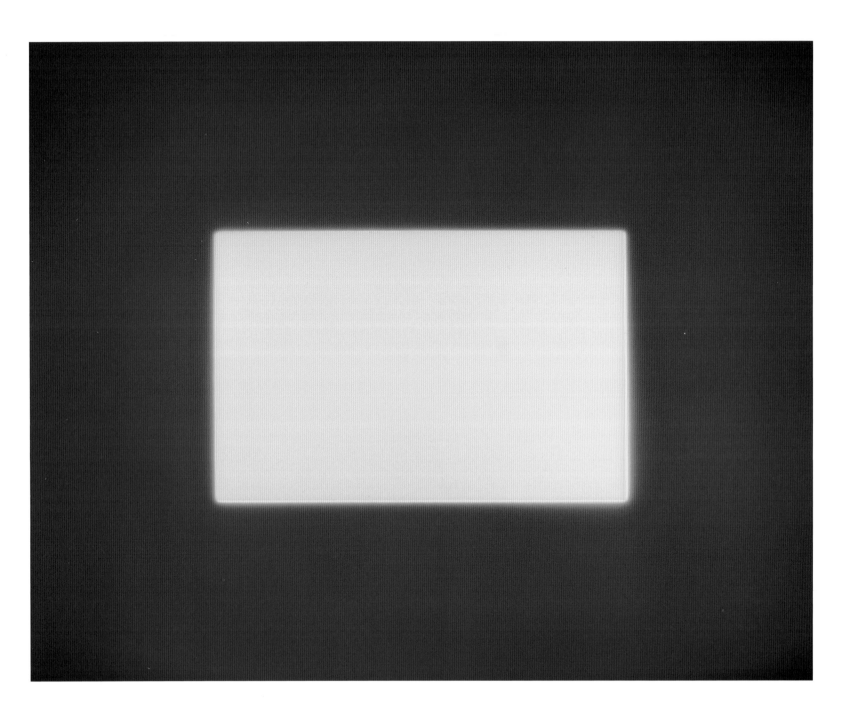

Year Two, Cobolt 1
September 2007
Oil, water, light, dye destruction print
40.5 x 50.5 cm / 16 x 20˝

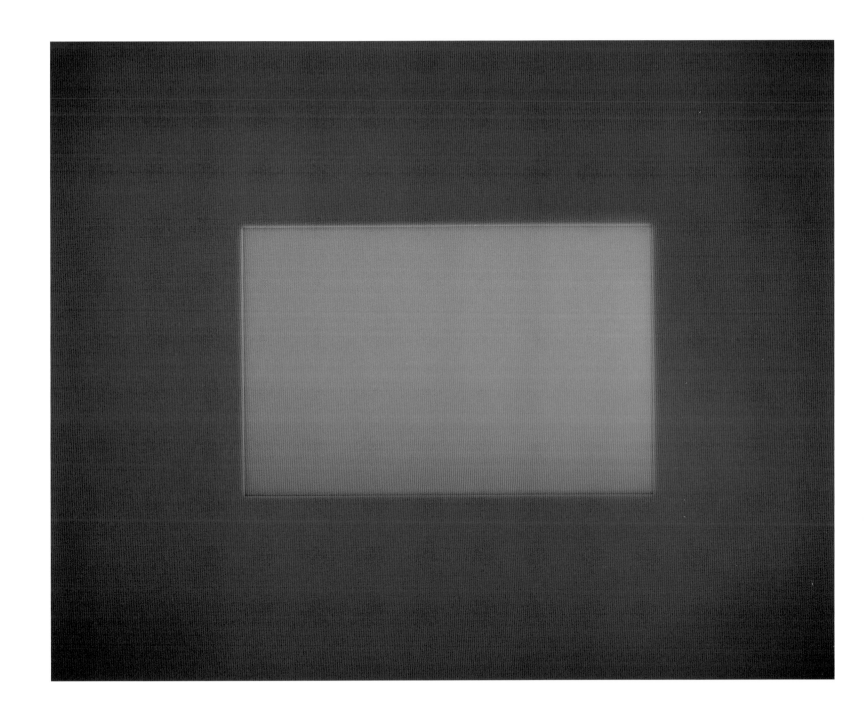

Year Two, Cobolt 8
September 2007
Oil, water, light, dye destruction print
40.5 x 50.5 cm / 16 x 20˝

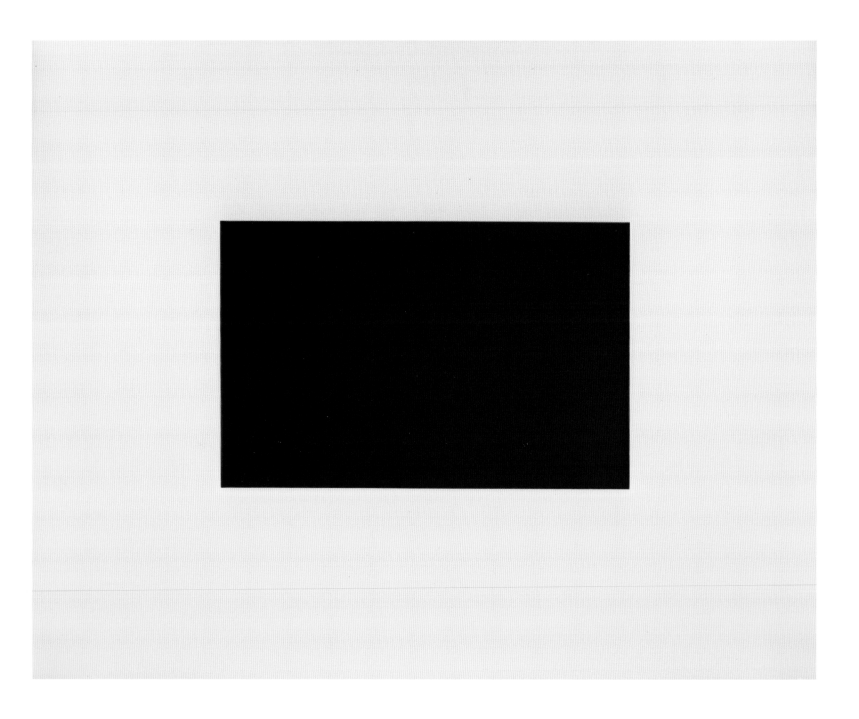

Year Two, Cobolt 7
September 2007
Oil, water, light, dye destruction print
40.5 x 50.5 cm / 16 x 20˝

Year Two, Cobolt 5
September 2007
Oil, water, light, dye destruction print
40.5 x 50.5 cm / 16 x 20˝

Year Two, Tourmaline 1
October 2007
Oil, water, light, dye destruction print
40.5 x 50.5 cm / 16 x 20˝ (detail)

Year Two, Tourmaline 2
October 2007
Oil, water, light, dye destruction print
40.5 x 50.5 cm / 16 x 20˝ (detail)

Year Two, Tourmaline 3
October 2007
Oil, water, light, dye destruction print
40.5 x 50.5 cm / 16 x 20˝ (detail)

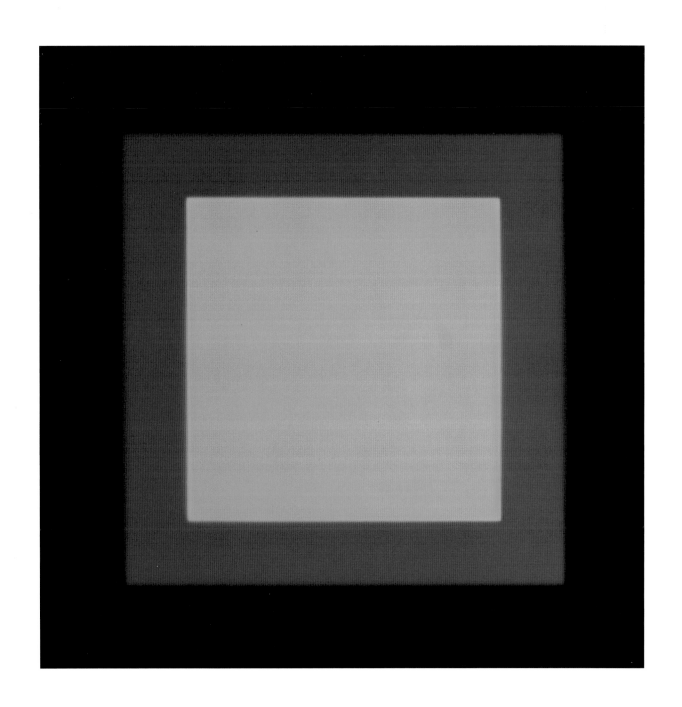

Year Two, Tourmaline 4
October 2007
Oil, water, light, dye destruction print
40.5 x 50.5 cm / 16 x 20˝ (detail)

Year Two, Tourmaline 6
October 2007
Oil, water, light, dye destruction print
40.5 x 50.5 cm / 16 x 20˝ (detail)

Year Two, Tourmaline 5
October 2007
Oil, water, light, dye destruction print
40.5 x 50.5 cm / 16 x 20˝ (detail)

Year Two, Tourmaline 7
October 2007
Oil, water, light, dye destruction print
40.5 x 50.5 cm / 16 x 20˝ (detail)

Year Two, Tourmaline 8
October 2007
Oil, water, light, dye destruction print
40.5 x 50.5 cm / 16 x 20˝ (detail)

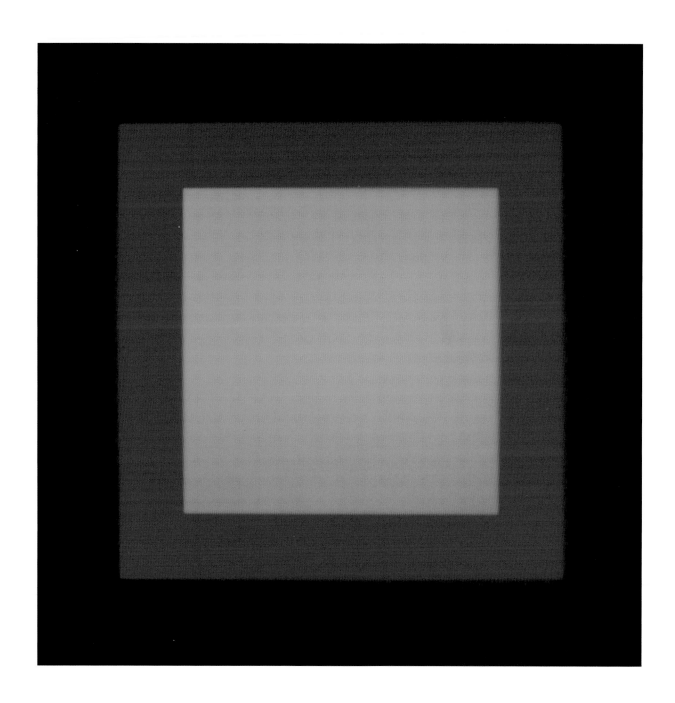

Year Two, Tourmaline 10
October 2007
Oil, water, light, dye destruction print
40.5 x 50.5 cm / 16 x 20˝ (detail)

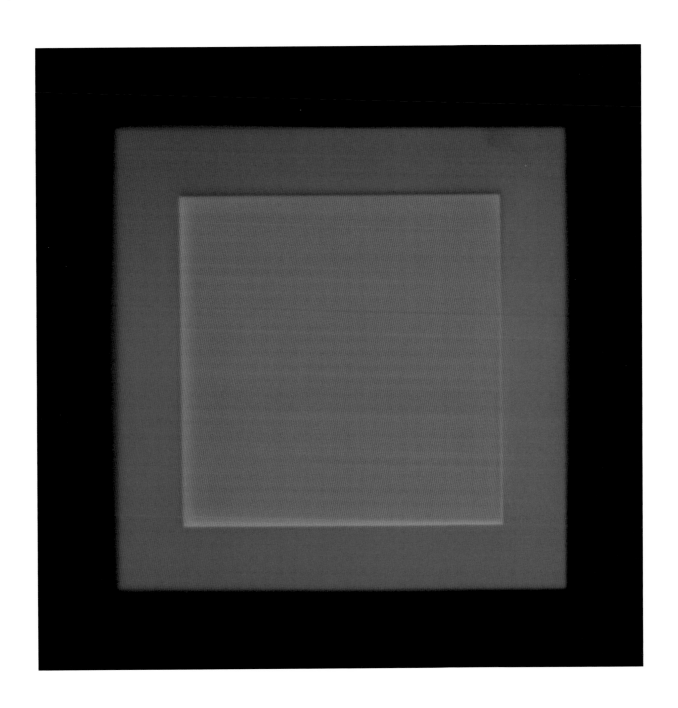

Year Two, Tourmaline 9
October 2007
Oil, water, light, dye destruction print
40.5 x 50.5 cm / 16 x 20˝ (detail)

Year Two, Batholith 10
November 2007
Water, light, dye destruction print
40.5 x 50.5 cm / 16 x 20˝

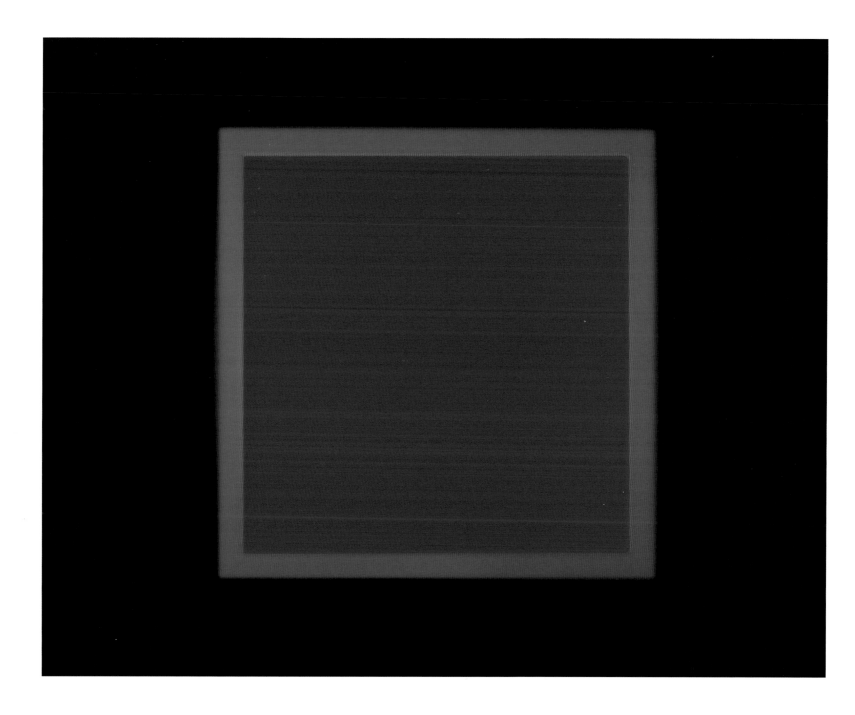

Year Two, Batholith 3
November 2007
Water, light, dye destruction print
40.5 x 50.5 cm / 16 x 20˝

Year Two, Batholith 1
November 2007
Water, light, dye destruction print
40.5 x 50.5 cm / 16 x 20˝

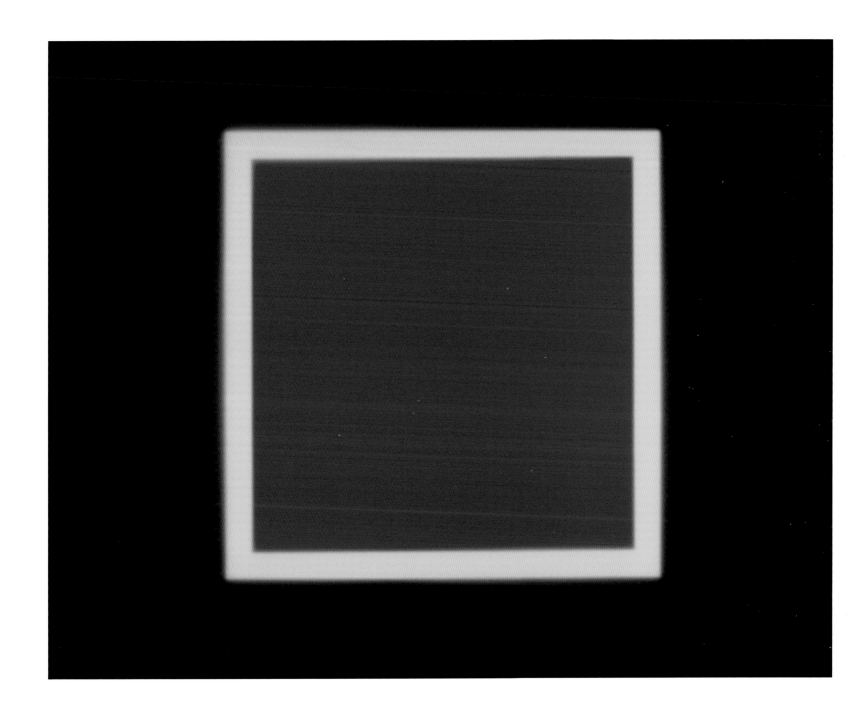

Year Two, Batholith 2
November 2007
Oil, light, dye destruction print
40.5 x 50.5 cm / 16 x 20˝

Year Two, Batholith 7
November 2007
Water, light, dye destruction print
40.5 x 50.5 cm / 16 x 20˝

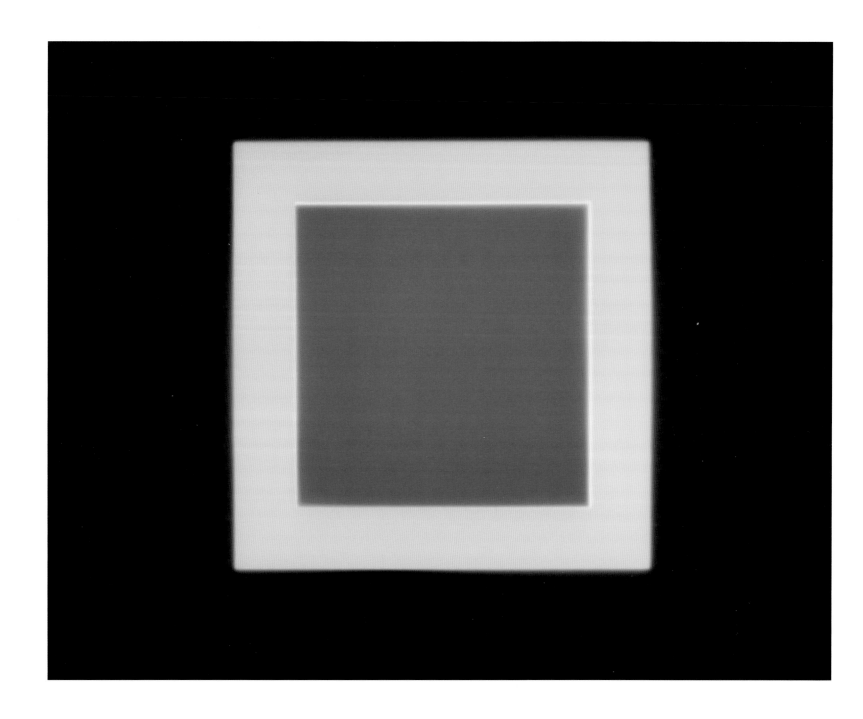

Year Two, Batholith 6
November 2007
Water, light, dye destruction print
40.5 x 50.5 cm / 16 x 20˝

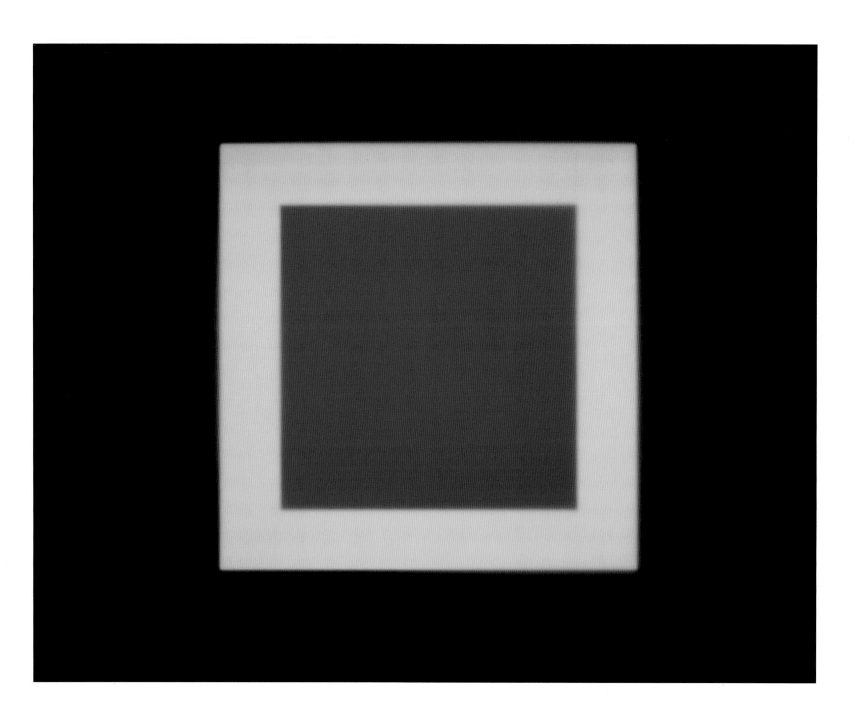

Year Two, Batholith 5
November 2007
Water, light, dye destruction print
40.5 x 50.5 cm / 16 x 20˝

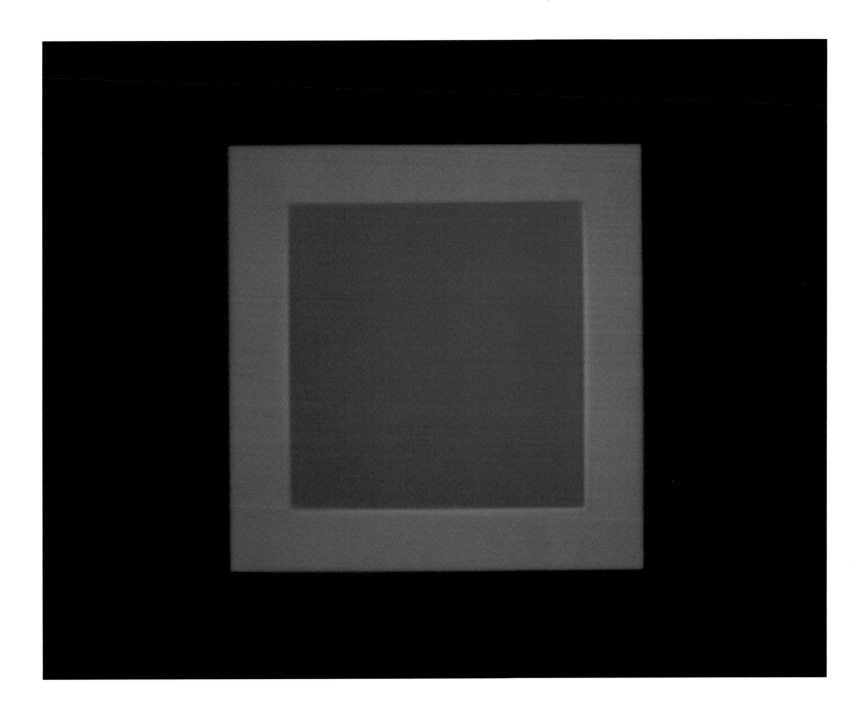

Year Two, Batholith 8
November 2007
Oil, light, dye destruction print
40.5 x 50.5 cm / 16 x 20˝

Year Two, Batholith 9
November 2007
Oil, light, dye destruction print
40.5 x 50.5 cm / 16 x 20˝

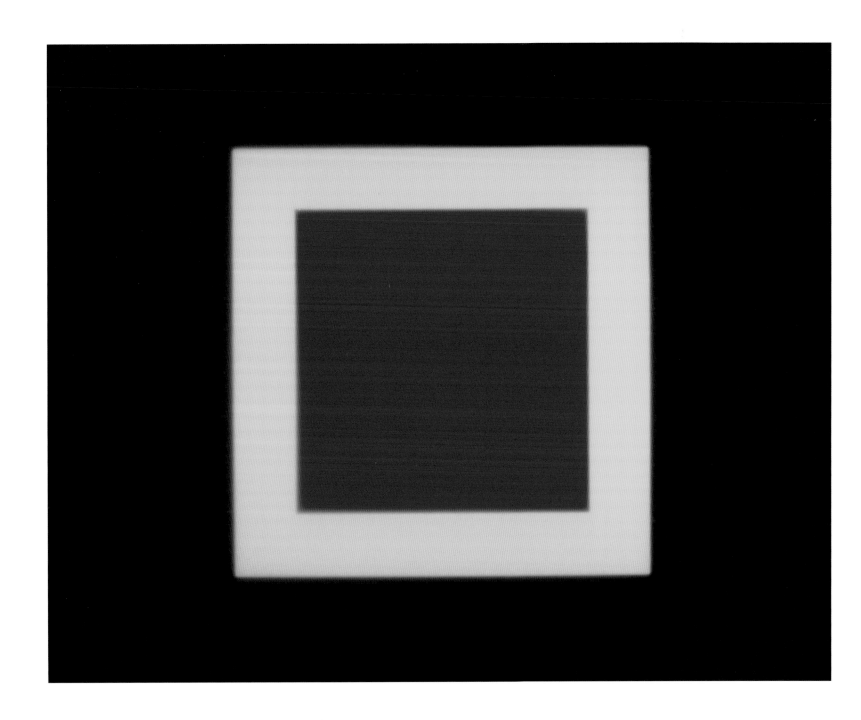

Year Two, Batholith 4
November 2007
Oil, light, dye destruction print
40.5 x 50.5 cm / 16 x 20˝

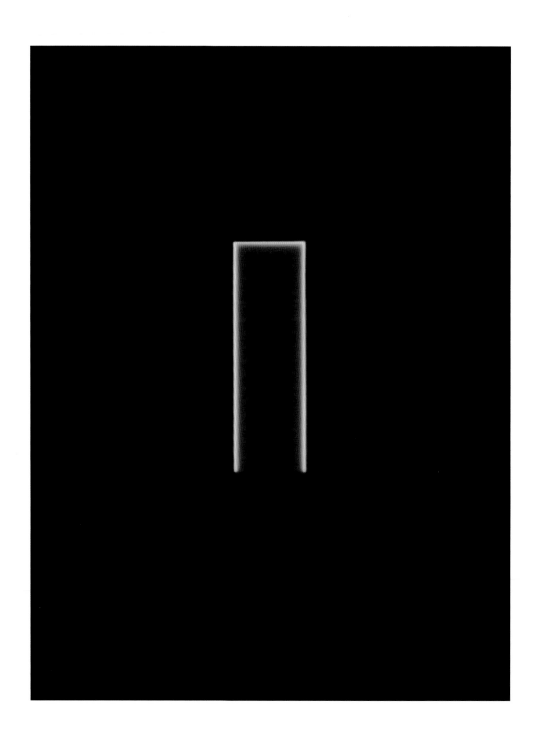

Year Two, Lead 1
December 2007
Oil, light, dye destruction print
50.5 x 40.5 cm / 20 x 16˝

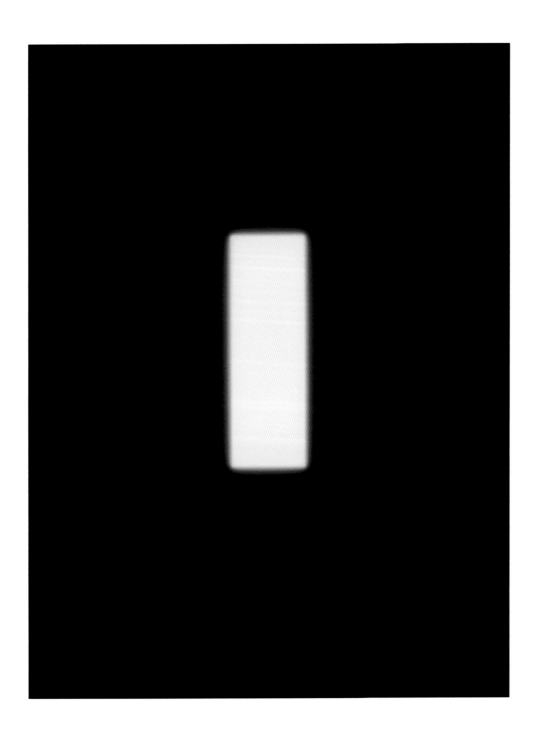

Year Two, Lead 8
December 2007
Oil, light, dye destruction print
50.5 x 40.5 cm / 20 x 16˝

Year Two, Lead 2
December 2007
Oil, light, dye destruction print
50.5 x 40.5 cm / 20 x 16˝

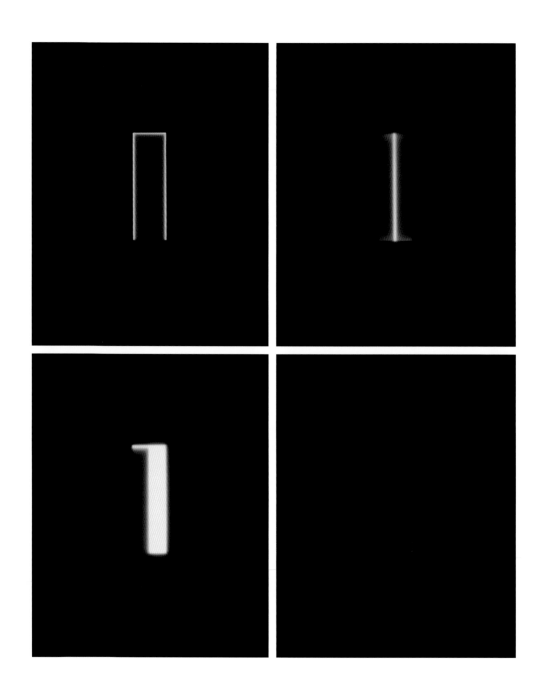

Year Two, Lead 1–10
December 2007
Oil, light, dye destruction print
50.5 x 40.5 cm / 20 x 16˝ (each work)

2008–2010

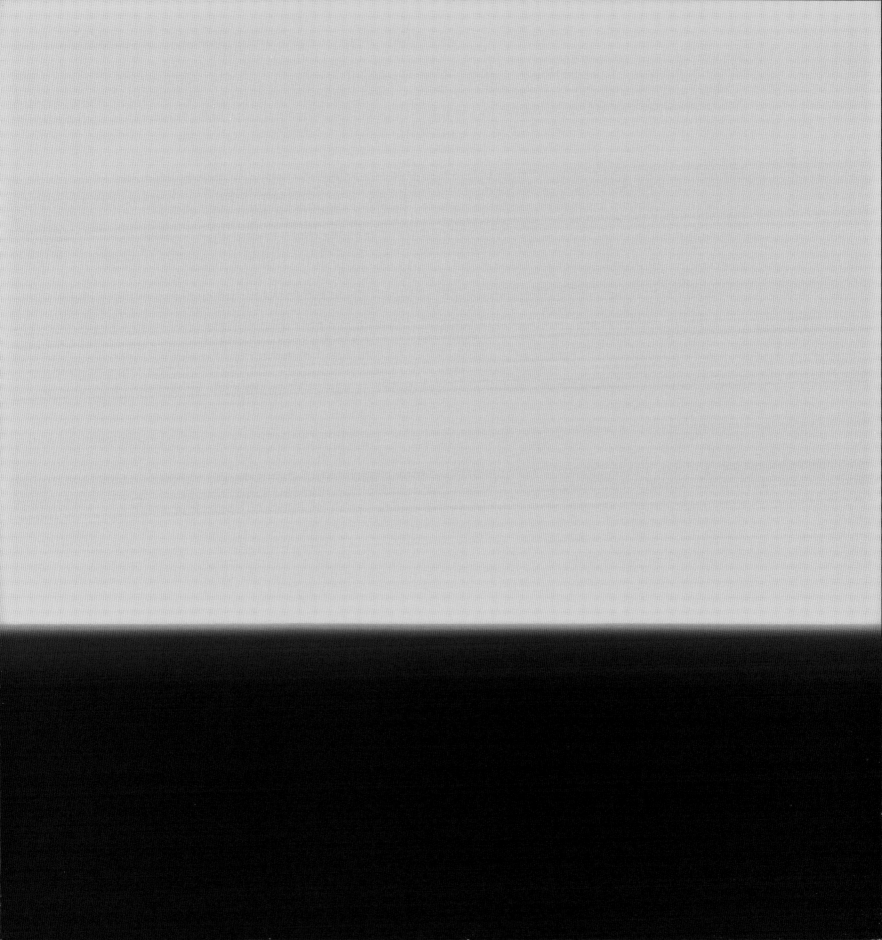

Gabriel
February 2008
Oil, water, light, dye destruction print
40.5 x 50.5 cm / 16 x 20˝

The Warm Winter Sun
2008
Oil, light, dye destruction print
50.5 x 40.5 cm / 20 x 16˝

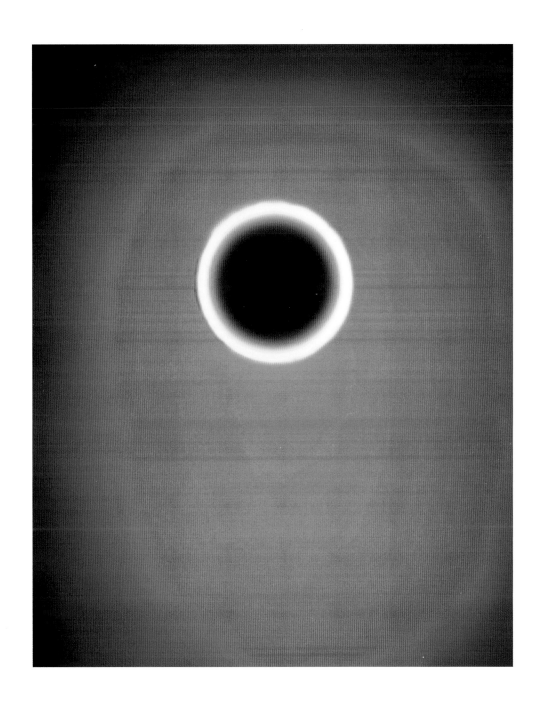

The Late Winter Sun
2008
Oil, light, dye destruction print
50.5 x 40.5 cm / 20 x 16˝

Last Evenings
April 2008
Oil, water, light, dye destruction print
202.5 x 50.5 cm / 80 x 20˝

Ascending
April 2008
Oil, water, light, dye destruction print
202.5 x 50.5 cm / 80 x 20˝

Right and opposite (detail)
Red Yellow Blue
May 2008
Oil, water, light, dye destruction print
202.5 x 50.5 cm / 80 x 20″

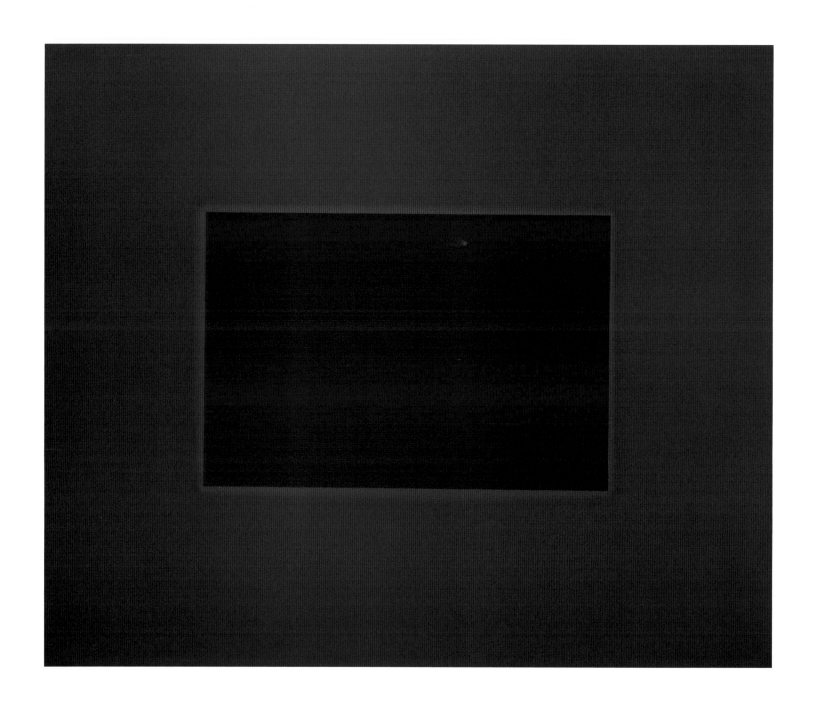

Quenching the Red
September 2008
Water, light, dye destruction print
51 x 61 cm / 20 x 24˝

Blue Gazing
September 2008
Water, light, dye destruction print
51 x 61 cm / 20 x 24˝

The Blue Clearing
and *Golden Dwelling*
August 2008
Installation: Ingleby Gallery, Edinburgh
November 2009–January 2010

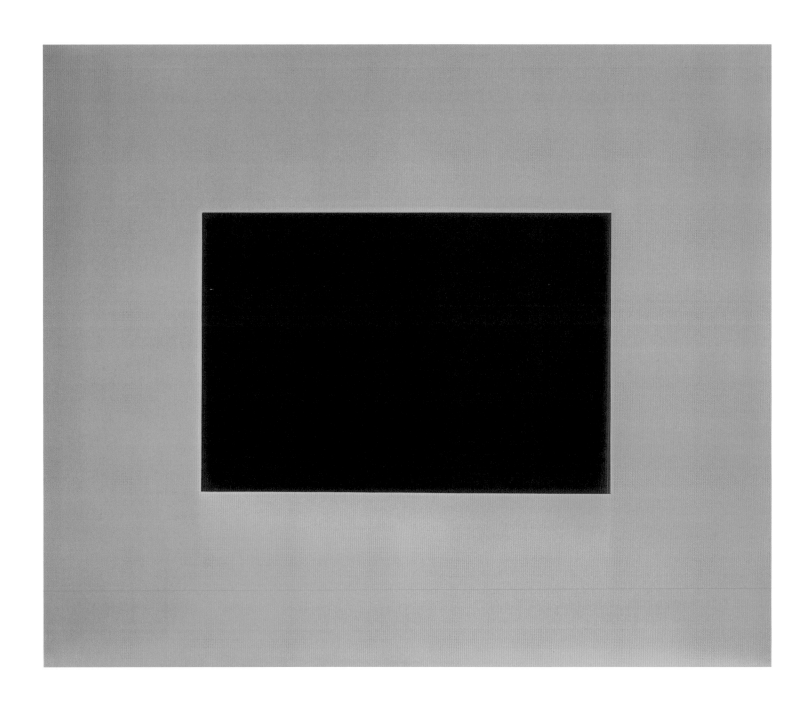

The Blue Clearing
August 2008
Oil, water, light, dye destruction print
51 x 61 cm / 20 x 24˝

Golden Dwelling
August 2008
Oil, water, light, dye destruction print
51 x 61 cm / 20 x 24"

Summer Warm
2008
Oil, water, light, dye destruction print
50.5 x 82 / 20 x 32½˝

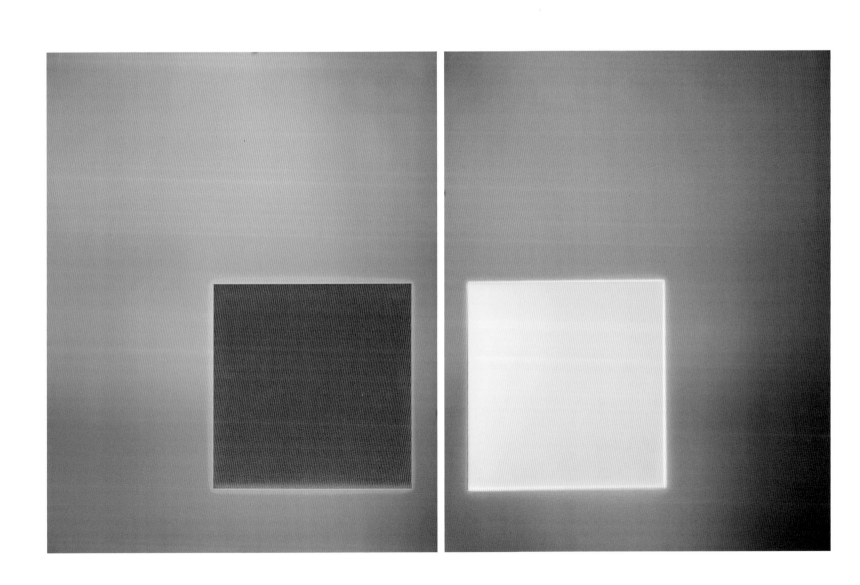

Blue in Blue

Spring 2009
Water, light, Lambda c-print
from dye destruction print
143.5 x 204 cm / 56½ x 80˝
Installation: Ingleby Gallery, Edinburgh
November 2009–January 2010

Opposite and overleaf
White in Blue
Late Winter 2009
Water, light, Lambda c-print
from dye destruction print.
143.5 x 204 cm / 56½ x 80˝
Installation: Ingleby Gallery, Edinburgh
November 2009–January 2010

Overleaf
Blue Yellow Red
Summer 2009
Installation: Ingleby Gallery, Edinburgh
November 2009–January 2010

GALLERY II

Blue Yellow Red
Summer 2009
Oil, water, light, Lambda c-print
from dye destruction print
143.5 x 264.7 cm / 56½ x 104˝
Installation: Ingleby Gallery, Edinburgh
November 2009–January 2010

Orange Aqua
Late Summer 2009
Oil, water, light, Lambda c-print
from dye destruction print
204.1 x 266.7 cm / 80 x 105˝
Installation: Ingleby Gallery, Edinburgh
November 2009–January 2010

Gaze (ii)
Winter 2009/2010
Water, light, Lightjet c-print
from dye destruction print
224 x 254 cm / 88 x 100˝ (detail)

Gaze (i)
Winter 2009/2010
Water, light, Lightjet c-print
from dye destruction print
224 x 254 cm / 88 x 100˝ (detail)

Beckoning (i)
Winter 2009/2010
Water, light, Lightjet c-print
from dye destruction print
193 x 224 cm / 76 x 88˝ (detail)

Beckoning (ii)
Winter 2009/2010
Water, light, Lightjet c-print
from dye destruction print
193 x 224 cm / 76 x 88˝ (detail)

The Enclosure
Winter 2009/2010
Oil, light, Lightjet c-print
from dye destruction print
224 x 254 cm / 88 x 100˝ (detail)

THE MAJESTY OF DARKNESS

ADAM NICOLSON

DARK WITH EXCESSIVE BRIGHT

Garry Fabian Miller's images have for many years been looking for the beauty and mystery of brightness in the dark. It is something that has always stalked the modern imagination. In the summer of 1575 Queen Elizabeth arrived on her progress through the English Midlands at Kenilworth Castle, decorated by her favourite and sometime lover the Earl of Leicester. She found it lit up like a liner sailing through the Warwickshire woods:

> euery room so spacious so well belighted and so hy roofed within: So seemely too sight by du proportion without: a day time, on euerye side so glittering by glasse; a nights by continuall brightnesse of candel, fyre, and throogh torch-light, transparent through the lightsom wyndz az it wear the Egiptian Pharos re-lucent vntoo all the Alexandrian coast... radiant as though Phoebus for hiz eaz woold rest him in the Castl, and not euery night so travel dooun vnto the Antipiodes.[1]

In the dark, the lights, it was said, glimmered through the branches of the surrounding woods "not unlike the beams of the Sun through the crannels [crevices] of a wall". It is the most cinematic of visions: the Sun himself, exhausted after his day's work crossing the heavens, lies down on the cushions and sofas which the Earl has provided for him, his brightness undimmed, intolerable inside the rooms but mysterious and powerful beyond them, like a caged star, a lantern for the world.

Or there is Milton a century later. Hell in *Paradise Lost*, famously, was "A dungeon horrible", from whose flames "No light; but rather darkness visible/Served only to discover sights of woe." The blind poet of human loss is all too familiar with a darkness in which tragedy has never been clearer. But there is another light-darkness in the poem, the conceptual twin and opposite of Satan's hellishly lightless light. In Book III of *Paradise Lost*, Milton addresses God directly, describing him on

his throne. If you looked straight at him, Milton says, he would be invisible, human eyesight useless, as if you were staring at the sun. But when God limits his brightness with a mistiness, and

> shad'st
> The full blaze of thy beams, and through a cloud
> Drawn round about thee like a radiant Shrine,
> Dark with excessive bright thy skirts appeer.

In the stream of magnificence with which Milton bathes his vision of Heaven, that is among the most poignant of images: the blind poet, imagining a brightness so great that its effect is darkness, an overwhelming cosmos of light filling the mind of a man who saw no light at all. It is clear that there is no religious content in Fabian Miller's imagery but it is just as clear that these fused polarities of cosmic presence and absence are what his visual imagination is addressing.

A century later, Milton's dark-lightness of the divine presence became a centrepiece of Edmund Burke's 1756 essay on the Sublime. Light, the young Irish lawyer told his audience, was obviously useful in "its bare faculty of showing other objects". But he wasn't interested in that. "Mere light is too common a thing to make a strong impression on the mind, and without a strong impression nothing can be sublime." The sublimity of light and its ability to convey the power of the otherworldly, Burke maintained, lay in its intimate and contradictory relationship to darkness. For Burke, Milton was the great actor-manager of the metaphysical, "entirely possessed with the power of a well-managed darkness". And here Fabian Miller joins his tradition: he is putting on a show, which requires ingenuity and technical expertise and which uses those qualities to introduce his audience to the sublime, to something which exudes ambivalence, the transient-universal, the dark-light, the miniature vastness of imagined worlds.

These are great and famous instances but it is one of the paradoxes of English poetic culture that its central tradition has for so long been enraptured by halfworldliness of this kind, by a sense of the power and beauty that emerges when conditions are marginal and transitional. This is not about chiaroscuro, the subtle delineation of form by the interplay of light and shade. It is a polarisation of that, a looking deep into the dark in the hope and even expectation that some other bright reality might appear there. Rothko said that colour for him was "merely an instrument to see beyond the form and the materiality, not to another materiality but to an immateriality". That is what this bright/dark margin is about too: a gateway to another world.

THE GREAT PRIVATIONS

On the simplest and gentlest level, Night is the vehicle for this otherworldiness. Night diminishes the perceived world but in doing so enhances its possibilities. Night is when there is a sense of openness, of barriers being down, antennae alert, of knowing that you need to feel your way through the wood, of the underworld being roused, of the eyes not seeing what needs to be seen. Above all in the light of the summer moon, when the moonlight makes everything that is present seem

immaterial and everything absent at least possible, night opens the gap between what is here and what might be here, between the actual and the potential. In its obscurities, night can make the world seem full. It is as if the world turns pregnant in the dark.

Although this is not a religious but a psychological question, religion does provide one of the languages by which that pregnancy of the dark can be addressed. Night, for the seventeenth century Welsh divine Henry Vaughan, is

> God's silent, searching flight:
> When my Lord's head is filled with dew, and all
> His locks are wet with the clear drops of night;
> His still, soft call;
> His knocking time; the soul's dumb watch,
> When Spirits their fair kinred catch.

This is the beginning of it. Night provides a vision of the pregnant world. But that pregnancy requires a kind of withdrawal, of the world diminishing as you watch, a diminution that leaves, oddly enough, not something less but something more. It is a world that doesn't bombard you but suggests and invites, is "wet" in Vaughan's marvellous word, but is also a net, almost cat-like, or owl-like, alert in the quietness and hungry for other life. There is nothing casual or indifferent here. Night trails its skirt as you advance towards it and your non-sensory understanding floods into the room which that invitation provides.

Burke's word for this withdrawal into a pregnant world is *privations*: "All general privations are great", he wrote in his essay on the Sublime: "Vacuity, Darkness, Solitude and Silence". They are not objects. They are not great in themselves but are great because they do impose or define. They withdraw and that discretion is their greatness. They provide a gateway to otherworldliness or at least to a zone into which otherworldliness can seep. When Keats wrote about negative capability in a letter to his brother in December 1817 he described—this was in a conversation with a friend—how

> several things dovetailed in my mind, & at once it struck me, what quality went
> to form a Man of Achievement especially in literature & which Shakespeare
> possessed so enormously—I mean Negative Capability, that is when man
> is capable of being in uncertainties, Mysteries, doubts without any irritable
> reaching after fact & reason.

The pregnant possibility, Keats thinks, the pre-defined and mysterious condition, exists not only in the reality of the world but in the mind of the person ready to let things be. 'Negative capability' is the state in which the imagination and the otherworldly are in communication. Otherworldliness is openness. Many of Fabian Miller's images address exactly this state, where the definitions of inner and outer, real and unreal, familiar and strange, solid and immaterial seem to dissolve, or at least to be in flux.

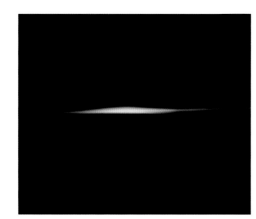

Thoughts of the Night Sea, Lucent 4
2001
Water, light, dye destruction print
52 x 66 cm / 20½ x 26″

THE FIRST OTHERWORLD

The roots of much of this are in Homer. But what happens there is not entirely recognisable now. It is always said that Homer's heroes did not attach much value to the otherworldly. For Hector, Odysseus, Achilles and the others what was good was here, in this world. Honour, fame, courage, riches: all might outlast time but all were attributes of the world as they knew it every day. The Homeric word for "glorious" is the same as the word for "shining" or even "well-lit". Glory happens in the daytime. Homeric heroism doesn't relish any Keatsian half-light or Miltonic transcendent glow, but the full sun of the eastern Mediterranean. For these Greeks, there is no afterlife worth having. In battle, old age or at sea, death was no more than the departure of the psyche to another, less interesting, lightless and juiceless world.

But that cannot entirely be true. Much of the poetic grip in the Homeric poems comes from scenes set at night, from those moments when the camp fires of the enemy seem as thick as stars on the opposite side of a valley, or when a storm rages across the sea at night and the real stars become invisible to the navigators. So, when in the middle of the Odyssey, Odysseus, with his crew of time- and sea-worn sailors, visits Hades, he is said to be arriving at the diminished, at a world which is less than this one. His men become cold and frightened. The coast is desolate, fringed with tall poplars and with willows whose seed blows in the wind. It is everything the world of the heroes is not: dark, colourless, silent and mournful, like a northern place, away from the light and warmth of the sea and lands they knew. This is the first otherworld in Western literature.

Crowds of the dead drift up to confront Odysseus's crew. The ghosts, the psyches, shuffle towards them; their limbs are strengthless. Hell is the absence of life, the removal from the world of love and warmth which is the defining glory of life on earth. It is the house of loss. Only when Odysseus sprinkles in front of him all the good and fruitful things of the world—milk, honey, wine, water, white barley flour— and adds to them the hot blood of newly slaughtered lambs, and only when he allows the ghosts to sip at that life-blood, does the power of speech, the sense of human communicability, return to the spirits.

As Odysseus stands there, with the tears running down his cheeks, he sees the ghost of Achilles coming towards him, the greatest of all the warriors, the fastest and fiercest among them, and now the greatest among the dead. His face is mournful and Odysseus tries to console him. Achilles answers coldly: "Never try to sweeten death for me. If I had a chance of living on earth again, I would rather do that as a slave of another, some landless man with scarcely enough to live on, than lord it here over all the dead that have ever died." For this ashy wraith, any taste of life, of the fully lit world, however humble, would be preferable to the half-lit half-existence of senseless wastedness to which he is condemned. The purity of death holds no attraction for him. The only world worth having is the one Odysseus is still alive in, the one in which the sun shines and glory is possible.

For all that, there is nevertheless a powerful allure in that sad and Gothic landscape. It undoubtedly inspired Dante's journey into Hell and coloured Milton's vision. Homer's extraordinarily powerful psychological geography is based on the understanding that this Odyssey is not really a journey through the Mediterranean but through Odysseus's heart. The places he is exploring are parts of himself and if he looks across the boundary

to the place where the ghosts of the great all gather, he is seeing a half-hidden country in which another truth seems to lurk. In the dimness of Hades, he is glimpsing both the universe and hidden parts of himself. And that is the deep paradox of darkness: that only in the dark are some of the deepest truths visible. Only when outlines are obscure can one imagine the whole of what is being said.

RELAXING THE SOLIDS

Withdrawals, meaning in the dark, a state of uncertainty, 'wetness', pregnancy, flux: these are also Fabian Miller's gateways to that combined inner-and-other world. It can be no coincidence that sexual and bodily metaphors hang about them all. Otherworldliness appears only when all ordinary coordinates are suspended and that is also the condition of desire, the softening of the self and its boundaries, an interpenetration of self and other. According to the young and highly desirous Burke, this is what happens when confronted with something you long for.

> The head reclines something on one side; the eyelids are more closed than usual, and the eyes roll gently with an inclination to the object, the mouth is a little opened, and the breath drawn slowly, with now and then a low sigh; the whole body is composed, and the hands fall idly to the sides. All this is accompanied with an inward sense of melting and languor. From this description it is almost impossible not to conclude, that Beauty acts by relaxing the solids of the whole system.

The creation of conventional order, of a too clearly ordered order, seems weak and trivial when set against these realities of molten margins, unravelling worlds, eroding certainties and liquifying identities. The poetry of Fabian Miller's images, as of the tradition from which he comes, draws its lifeblood not from things growing, nor as they are dead, but as they are, perhaps half-erotically, unmade. And so it is the suggestion, the half-said thing, the half-known place which turns out to be more gripping than the flatly said, the blankly known and the clearly aligned.

This molten margin has been a constant in the English mind, from the great Anglo-Saxon poems of disintegration and ruin, to Sir Thomas Malory's *Morte Darthur* where love and death dance through an imagined and fading world, to Tennyson and TS Eliot: all of them find a deep, rich and melancholy music in places that are dissolving as you watch. Tennyson's Arthur, to take a climactic moment, has been wounded at the last great battle of Camlann:

> then, because his wound was deep,
> The bold Sir Bedivere uplifted him,
> Sir Bedivere the last of all his knights,
> And bore him to a chapel nigh the field,
> A broken chancel with a broken cross,
> That stood on a dark strait of barren land.
> On one side lay the Ocean, and on one
> Lay a great water, and the moon was full.

Thoughts of the Night Sea, Lucent 3
2001
Water, light, dye destruction print
52 x 66 cm / 20½ x 26˝

Everything here is on the edge of certainty: this place seems to be far away and long ago; the king is hurt and his knights are gone; even Bedivere's brother Gawain is dead; the knight carries his king like a wounded child; there is a chapel but it is broken; the land narrows between the two waters; even the moon is at the full, on the point of decline, lighting the darkness only with the glimmer of a half-light. It is the place that Malory, and Eliot after him, called "the Waste Londe".

REMEMBERING THE SHADY NOTHING

Perhaps beauty is to do with a sense of the past; and the beautiful, of its essence, is the distant, not the vivid but the sad. For the Greeks, Memory was the mother of the muses. To dance or sing or to paint, even maybe to speak, at least with eloquence, was to remember. And so to portray distant worlds, as Fabian Miller does, as if looking at them either from far away or long ago, is in this Greek sense to dramatise the process of discovering the beautiful. There is a Platonic psychology of perception at work here: for the Platonists, understanding was to remind yourself of things which you once knew but which the flood of immediate sensory perceptions, gathered every day of your daily life, had obscured.

In this sense, understanding consists not in acquiring the stuff of knowledge, gaining ever more facts and perceptions, but the opposite of that, clearing away the detritus, groping back into the regions of the mind or the soul beyond sensory memory. The Greek word for truth is *a-letheia*, which means the "un-forgetting", the pulling oneself away from the waters of Lethe, the river of forgetfulness, in which we are all swimming every day. The name Lethe is related to lethargy, latency, the hidden thing. So truth is the un-hidden thing, the thing made alive, what was once inert and is now living in your mind.

This is almost the opposite of post-enlightenment theories of understanding, which assume that people know nothing except what they have learned. But if understanding is in fact a process of unforgetting, then to consider the otherworldly is a process of unclogging the mind, suspending the worldliness you have acquired, giving truth some room to make itself clear. This is exactly what the great privations and the visions of an unraveling world all do. "All artists whether they know it or not", David Jones, the poet, painter and letterer wrote, "are in fact 'showers forth' of things which tend to be impoverished, or misconceived, or altogether lost or wilfully set aside...." The making of beauty is an act of redemption. It pulls back into consciousness things which consciousness would otherwise deny. And the suggestiveness of the almost seen, which is the realm in which Fabian Miller thrives, is a dramatisation of that clawing back into the half-forgotten world.

This vision of another, more perfect world almost to hand reaches its peak in the prose meditations of Thomas Traherne, an obscure, mid-seventeenth century Herefordshire cleric.

The world is a mirror of Infinite Beauty, yet no man sees it. It is a Temple of Majesty, yet no man regards it. It is a region of Light and Peace, did not men disquiet it. It is the Paradise of God. It is more to man since he is fallen than it was before. It is the place of Angels and the Gate of Heaven.

Over and over again Traherne urged on his readers the necessary scale of a true vision:

> The WORLD is not this little Cottage of Heaven and Earth. Though this be fair, it is too small a Gift. When God made the World He made the Heavens, and the Heavens of Heavens, and the Angels, and the Celestial Powers. These also are parts of the World.

But it is in his great unifying vision of the interflood between the natural world, the otherworld and the world of the human heart that Traherne binds up all the possibilities of light in the darkness:

> You never enjoy the world aright, til the Sea itself floweth in your veins; til you are clothed with the Heavens and crowned with the stars and perceive yourself to be the sole heir of the whole world. Til your spirit filleth the whole world and the stars are your jewels; til you are intimately acquainted with that shady nothing out of which the world was made.

It may be that a sense of revelation comes from those places which invite you to cross boundaries, which suggest and hint at other conditions, which know about the past, play with obscurity, richness and strangeness, which flirt even with a sense of their own absence. Wordsworth used to write his poetry when walking along the public roads at night, because those were the circumstances in which he could best feel that the world had other worlds folded into it. On the empty, palely gleaming road, his own past, his own self and his sense of the spiritualised within the material world could all take their place in his mind. It is one of the reasons that so many of Garry Fabian Miller's rich and otherwordly images seem to hint at an island condition, a half-distant world removed beyond the sea, or the cosmic equivalent of that, a dark planet burning in an even darker sky. This is not darkness visible—there is nothing Satanic here— but it is perhaps the better twin of that, the light-filled dark, "the majesty of darkness" in Milton's phrase.

1 Laneham, Robert, *Letter Describing a Part of the Entertainment unto Queen Elizabeth at the castle of Kenilworth 1575*, London, 1907, p. 48.

The Night Cell
Winter 2009/2010
Water, light, Lightjet c-print
from dye destruction print
193 x 224 cm / 76 x 88˝ (detail)

WRITERS

Nigel Warburton is Senior Lecturer in Philosophy at the Open University. He has published a number of articles on photography and edited a volume about Bill Brandt. His other books include *Ernö Goldfinger: the life of an architect*, *The Art Question*, and *Free Speech: A Very Short Introduction*. He regularly teaches courses on aesthetics at Tate Modern. For more information see www.nigelwarburton.com

Marina Warner is a writer of fiction, criticism, and cultural history; her works include short stories, novels, myths and fairy tales. Born in 1946 to an English father and Italian mother, she grew up in Cairo, Brussels, and Cambridge, England. She was shortlisted for the Booker Prize in 1988 for her book *The Lost Father*, and *From the Beast to the Blonde: On Fairy Tales and Their Tellers* won the Mythopoeic Award in 1996. She has curated exhibitions and written essays on art, newspaper articles and reviews; is a Fellow of the British Academy, Distinguished Visiting Professor at Queen Mary's, London, and Professor of Literature at the University of Essex. She was awarded a CBE in 2008 for her services to literature.

Adam Nicolson was born in 1957, the son of the writer Nigel Nicolson and grandson of Vita Sackville-West and Sir Harold Nicolson. He was educated at Eton College and Magdalene College, Cambridge and has worked as a journalist and columnist on *The Sunday Times*, *The Sunday Telegraph* and *The Daily Telegraph*. He is a winner of the Somerset Maugham, William Heinemann and Ondaatje Prizes for a variety of books on English history, landscape and the sea. He has presented several television and radio series and is a Fellow of the Royal Society of Literature and of the Society of Antiquaries of Scotland. He is married with five children and lives at Sissinghurst in Kent.

Garry Fabian Miller was born in Bristol in 1957. His earliest photographic works were socially engaged portraits in the mode of their time. In 1974 he undertook an intensive study of the remote island community of the Shetlands, an experience that strengthened his interest in rural communities, and his developing ideas about the potential of an artist's life lived outside the mainstream of metropolitan culture. The importance of place has since become a predominant theme throughout Miller's work and was at the heart of his first major body of work *Sections of England: The Sea Horizon* in 1976: 40 photographs taken from a fixed point on the roof of his home overlooking the Severn Estuary in which the photographic elements of lens and film and exposure remained constant so that the only change from frame to frame was in the time of day and the weather. The cumulative series presents a powerful study of time and place and were first shown as part of the Midland Open Exhibition at London's Serpentine Gallery in 1977 and in a fuller form in his first solo exhibition at the Arnolfini Gallery in Bristol in 1979.

In 1980, Miller moved to Lowfield Farm in a remote corner of Lincolnshire and since 1984 he has worked without a camera, using the techniques of early nineteenth century photographic exploration to experiment with the nature and possibilities of light as both medium and subject. His earliest camera-less photographs were made by inserting translucent objects, principally leaves, seedpods and flower heads, into an enlarger and using them as transparencies through which light passed onto photo-sensitive paper.

Since 1992 he has explored a more abstract form of picture-making by passing light through coloured glass and liquid and cut paper forms. In parallel he has explored the ideas of exposure, the quantities of light that are required to make things visible, or invisible, in the making of a picture. In sharp contrast to the photographic norm of exposures that last for a fragment of a second, Miller's work tends towards long exposures lasting anywhere between one and 15 hours. These unusual methods create alternative, luminous realities that shift from pure abstraction to imagined landscapes of the mind and the resulting pictures have tended to appear from the studio in series, each image leading to the next.

Amongst the most notable of these series are *Sons & Angels*, exhibited at Yokohama Museum of Art, Japan, 1995, and Museet fur Fotokunst, Odense, Denmark, 1996; *Petworth Windows*, exhibited Petworth House, West Sussex,

1999 and Cleveland Museum and Art Gallery, Ohio, USA, 2004; *Toward a Solar Eclipse*, exhibited Tate St Ives, 1999; *Thoughts of a Night Sea*, exhibited Tate Liverpool, 2001; *Burning*, exhibited Graves Art Gallery, Sheffield, 2002; *Night Towers*, exhibited Nichido Contemporary Art, Tokyo, Japan 2002; *Becoming Magma*, exhibited Victoria and Albert Museum, London, 2005; and *Exposure*, exhibited Ingleby Gallery, Edinburgh 2005.

As these various series evolved so did their scale and complexity: the finished pictures often forming large grids made up of several connected elements. In 2006, partly as a reaction against the physical and technical challenges of these composite works, and partly in response to the threat posed to his methods by the digital age—specifically the demise of light sensitive Cibachrome paper—Miller began an intense period of working on a smaller scale. Referred to as *Year One* and *Year Two*—this period of free experiment collated his accumulated knowledge into a body of work that presented a pattern book of ideas for the future.

Year One and *Year Two* formed the basis of exhibitions at the New Art Centre, Salisbury in 2007; Newlyn Art Gallery, 2008 and Abbot Hall Art Gallery in 2009, and paved the way for Miller's most recent experiments with large format images. These newest works use new printing processes to restore the balance of solid and liquid colour that defined those first experiments in Cibachrome of 30 years ago, and suggests an evolutionary moment in Miller's career: sharing the values of historical knowledge with the potential of the future. They were shown for the first time in the exhibition The Colours at Ingleby Gallery in 2010 and will take their place in the wider context of Miller's work in the exhibition Shadow Catchers at the Victoria and Albert Museum, London in 2010/2011.

Work by Miller is held in many collections worldwide including the Bibliotheque Nationale, Paris; The Fogg Art Museum, Harvard; the Museum of Fine Arts, Houston; the Metropolitan Museum of Art, New York and the Victoria and Albert Museum, London. Recent publications of note include *Tracing Light* by David Alan Mellor, PhotoWorks, 2001; *Thoughts of a Night Sea* by Lavinia Greenlaw, Merrell, 2002; *Illumine* by Martin Barnes, Merrell, 2005; *Exposure* by Ian Warrell, Ingleby Gallery, 2005, and *Year One* by Edmund de Waal, Ingleby Gallery, 2007.

Since 1989 Garry Fabian Miller has lived with his family at Homeland on Dartmoor in the South West of England.

ACKNOWLEDGMENTS

I would like to thank all the galleries who over the years have had faith in my work. Their support, and that of their clients, has made possible the creative life from which the pictures appear.

In particular, Marcus Bury and Sascha Hackel, early collectors of my work, who continue in their quiet friendship, Richard Ingleby and Kate Stevens for their unwavering support, clarity and meticulous care, Zara Horner, Christian Dillon and Dan Smernecki for the practical assistance that enables focused thinking in the studio.

Whilst making this book I have enjoyed sharing thoughts with Nigel Warburton, Marina Warner and Adam Nicolson all of whom have assisted me to better understand my own journey. Thanks also to Alex Wright for shaping the book's fine design.

Warmest thanks to John Bodkin, who in the two years since we met has become both friend and guide. Together we have explored a new kind of picture making, though I sense there is much yet to find. Thanks also to his colleagues at Dawkins Colour.

As always, my deepest thanks and love go to my family, Naomi, Lauren, Sam and Josh for making a home from which I can walk out, loved into the light. Without them, there would be the deepest dark.

Garry Fabian Miller, Midsummer 2010

Garry Fabian Miller would like to thank Hackelbury Fine Art for their support with this publication.
www.hackelbury.co.uk

PICTURE CREDITS

JOHN BODKIN
pp. 21, 31, 33–93, 100–104, 112–114

MICK DUFF
p. 98

GARRY FABIAN MILLER
pp. 1, 9–23, 25–28

HACKELBURY FINE ART
pp. 94–97, 99, 105

STEPHEN HOBSON
pp. 3, 29

INGLEBY GALLERY (JOHN MACKENZIE)
pp. 106–111

JOHN JONES
pp. 5, 6

NEW ART CENTRE
p. 8

STEVE TANNER
p. 7

COLOPHON

All works by Garry Fabian Miller, copyright the artist.

"Time and Light" copyright Nigel Warburton.
"Adynata—Time's Colour; Impossible Beauty"
copyright Marina Warner.
"The Majesty of Darkness" copyright Adam Nicolson.

Designed by Alex Wright at Black Dog Publishing.

Black Dog Publishing Limited
10a Acton Street
London WC1X 9NG
United Kingdom

Tel: +44 (0)20 7713 5097
Fax: +44 (0)20 7713 8682
info@blackdogonline.com
www.blackdogonline.com

British Library Cataloguing-in-Publication Data.
A CIP record for this book is available from the
British Library.

ISBN 978 1 907317 06 4

Black Dog Publishing Limited, London, UK,
is an environmentally responsible company.
The Colour of Time is printed on an FSC certified paper.

architecture art design
fashion history photography
theory and things

black dog
publishing

www.blackdogonline.com

london uk